PERSONAL WEB SITES

GLOUCESTER MASSACHUSETTS

ROCKPORT PUBLISHERS

<JOE_SHEPTER>

PERSONAL WEB SITES

/TOP DESIGNERS PUSH THE BOUNDARIES WITH EXPERIMENTAL
DESIGN AND GRAPHICS/

First published in the United States of America by
Rockport Publishers, Inc.
33 Commercial Street
Gloucester, Massachusetts 01930-5089
Telephone (978) 282-9590
Fax (978) 283-2742
www.rockpub.com

ISBN 1-56496-863-4
10 9 8 7 6 5 4 3 2 1

Book Design: Stoltze Design
Project Manager: Barbara Rummler

Printed in China

FOR MY MOTHER.

THANKS FOR READING ALL THE STUFF
THAT DIDN'T GET PUBLISHED.

PERSONAL WEB SITES

CONTENTS

PERSONAL WEB SITES
INTRODUCTION

ONE DAY IN THE AUTUMN OF 2000, WEB DESIGNERS AROUND THE WORLD AWOKE TO DISTRESSING NEWS. AS THEY PUSHED BACK THE MORNING HAZE WITH COFFEE, THEY LEARNED THAT KALIBER 10,000 WAS GONE.

IF YOU WERE UNAWARE OF THIS TRAGEDY, YOU'RE NOT ALONE. THE SITE IS VIRTUALLY UNKNOWN OUTSIDE OF THE WEB DESIGN UNDERGROUND. FOUNDED BY DANISH DESIGNERS MIKE SCHMIDT AND TOKE NYGAARD, IT DOES LITTLE MORE THAN PROVIDE UP-TO-THE-MINUTE NEWS ON PERSONAL SITES AND DESIGN EVENTS AROUND THE WORLD. AT THE TIME OF ITS SHUTDOWN, IT WAS LOGGING 3 MILLION VISITORS A MONTH AND COSTING SCHMIDT AND NYGAARD A SMALL FORTUNE IN HOSTING FEES. THEY HAD TO SHUT IT DOWN OR FACE BANKRUPTCY.

SUCH IS THE WORLD OF PERSONAL SITES: A WORLD SO INVISIBLE THAT IT LEAVES ITS BIGGEST STARS VIRTUALLY UNKNOWN AND SO POPULAR IT CAN CAUSE THEM SEVERE FINAN-CIAL DISTRESS. BUT WHAT ARE THESE SITES, AND WHY DID THEY SUDDENLY BECOME SUCH A CRAZE?

THOUGH NO ONE REALLY KNOWS WHO BUILT THE FIRST PERSONAL SITE, THE SCENE MORE OR LESS BEGAN WITH A SAN FRANCISCO ARTIST NAMED AMY FRANCESCHINI. INTERESTED IN COMPUTER ART, SHE WAS WORKING AT A PRINT SHOP WHERE SHE BECAME FRIENDS WITH A FRENCH PHOTOGRAPHER NAMED OLIVIER LAUDE. LAUDE WAS A LOCAL CHARACTER WITH A TALENT FOR COMING UP WITH INTERESTING IDEAS AND FINDING THE RIGHT PEOPLE TO EXECUTE THEM. HIS BRIGHT IDEA IN THIS CASE WAS FOR FRANCESCHINI TO HELP HIM PRODUCE AN ART MAGAZINE ON THE WEB. CALLED ATLAS, IT LAUNCHED IN 1996. WITH PUFFY FONTS AND THREE-DIMENSIONAL CHARACTERS, IT BECAME AN INSTANT HIT.

IN THE FIVE YEARS SINCE ATLAS, PERSONAL ARTWORK ON THE NET HAS GROWN INTO A WORLDWIDE ARTISTIC MOVEMENT. THERE ARE EXAMPLES IN THE UNITED STATES AND CANADA, IN AUSTRALIA AND JAPAN, IN GREECE, RUSSIA, SOUTH AFRICA, HONG KONG, ARGENTINA, SWEDEN, AND MALAYSIA. WALK INTO A PUB NEAR HOXTON SQUARE IN LONDON, AND YOU'LL HAVE NO TROUBLE FINDING SOMEONE WHO KNOWS ABOUT HUNGRY FOR DESIGN, A SITE BUILT BY BRAZILIAN DESIGNER NANDO COSTA. HEAVE A BRICK THROUGH THE BLACK ELEPHANT INTERNET CAFÉ IN CHISINAU, MOLDOVA (HOME OF $1/HOUR CONNECTIVITY) AND YOU'LL PROBABLY BRAIN SOMEONE LOOKING AT THE SURFSTATION PORTAL, WHICH HAILS FROM LUXEMBOURG CITY. FROM ONE SIDE OF THE GLOBE TO THE OTHER, THOUSANDS OF PEOPLE BELONG TO SOMETHING AND THEY DON'T EVEN HAVE A PROPER NAME FOR IT.

THE NAME THEY MOST OFTEN USE IS "PERSONAL SITES," AND THEY DON'T EVEN AGREE ON ITS MEANING. PERSONAL SITES ARE GENERALLY PRODUCED BY INDIVIDUALS, BUT THEY ARE NOT HOMEPAGES. THEY DON'T SHOW OFF PORTFOLIOS AND THEY AREN'T TRYING TO SELL ANYTHING. AT BEST, THEY ARE PURE ARTISTIC SPACES, A KIND GLOBAL FOLK ART WITHOUT ANY REAL ADMISSION REQUIREMENTS. SOME OF THEM FALL INTO GENRES, MOST FOLLOW TRENDS IN THE FIELD, BUT THERE IS NO AUTHORITY ON THE SITES OR ANY ORGANIZATION THAT RECOGNIZES THEM FOR WHAT THEY ARE.

THE REASON IS THAT PERSONAL SITES LIVE IN A NEVER-NEVER LAND SANDWICHED BETWEEN DESIGN AND ART. IN A LOT OF WAYS THEY ARE SIMILAR TO GRAFFITI, ANOTHER ART FORM THAT IS EASILY DISMISSED. GRAFFITI IS SOMETHING FEW PEOPLE TAKE SERIOUSLY, BUT IT IS AS REFINED AN ART AS ANY AND REQUIRES MANY SKILLS. YOU HAVE TO BE A GOOD PLAN-NER, AN EXPERT IN COLORS AND TEXTURES, A GOOD JUDGE OF COMPOSITION, AND THE PROUD OWNER OF A QUICK AND FLAWLESS HAND UNDER PRESSURE. BUT WHEN YOUR WORK IS DONE, IT'S ALMOST ENTIRELY A CIPHER. FEW PEOPLE UNDERSTAND IT; FEW KNOW ITS TECHNICAL DIFFICULTIES OR ARE UP-TO-DATE ON ITS STYLISTIC NUANCES. ALL THEY DO IS

SIMILARLY, A GOOD PERSONAL SITE REQUIRES MANY SKILLS. FIRST OF ALL, YOU MUST BE A DILIGENT WORKER AND AN EXCELLENT ORGANIZER OF YOUR TIME. YOU HAVE TO BE ABLE TO COME UP WITH YOUR OWN VOCABULARY AND CONCEPTS, AND MOST IMPORTANTLY YOU HAVE TO BE ABLE TO DEVELOP YOUR OWN PECULIAR RULES. BECAUSE A PERSONAL SITE ABOVE ALL IS NOT A PLACE WHERE YOU BREAK THE RULES, IT'S A PLACE WHERE YOU MAKE THEM. OUT OF AN INFINITE NUMBER OF POSSIBILITIES, A PERSONAL SITE SETS BOUNDARIES AND BUILDS A WORLD INSIDE THEM.

BUT WHY WOULD ANYONE DO ALL THIS? IN AN ESSAY TITLED "WHY I WRITE," GEORGE ORWELL ONCE SUMMED THE MOTIVATION OF INDIVIDUAL ARTISTS WITH A SINGLE, DISARMINGLY HONEST PHRASE: "SHEER EGOTISM." SUCCESSFUL PERSONAL SITES ARE VIEWED AND PRAISED AROUND THE WORLD BY HUNDREDS OF THOUSANDS OF PEOPLE. BUT BEYOND THAT, THERE IS ALSO THE POSSIBILITY OF MEETING NEW PEOPLE, THE CHANCE OF GETTING A BETTER JOB, OR THE DESIRE TO COMMUNICATE SOMETHING. SOME CLAIM IT'S AN EMOTIONAL OR CREATIVE RELEASE, AND THAT COULD WELL BE TRUE. BUT FOR MOST OF THEM, IT IS SIMPLY A WAY TO BE MEASURED, AND TO BECOME A NAME IN A FIELD THAT OFFERS FEW OTHER REWARDS.

THIS BOOK IS AN ATTEMPT TO TRY TO UNDERSTAND THESE SITES ON THEIR OWN TERMS. IT
DOES NOT CLAIM TO BE A COMPREHENSIVE LIST OF THE BEST ONES, OR EVEN AN AUTHOR-
ITATIVE SURVEY OF THEM. RATHER, IT'S AN ATTEMPT TO SHOW THE SCOPE OF THE MOVEMENT
AND SOME OF ITS HIGHER POINTS. MOST DESIGNERS WILL HAVE PROBLEMS WITH SOME OF
THE CHOICES OR DISAGREE HOTLY WITH THE CRITERIA BY WHICH THEY WERE CHOSEN. BUT
THESE SITES DO REPRESENT A UNIQUE, GLOBAL MOVEMENT THE LIKE OF WHICH THE WORLD
HAS NEVER SEEN BEFORE.

THE SITES IN THIS BOOK HAVE BEEN DIVIDED INTO SEVERAL CATEGORIES, BUT THESE ARE
CERTAINLY NOT RIGID, AND MANY OF THE SITES COULD HAPPILY OCCUPY TWO CATEGORIES,
OR NONE AT ALL. THERE IS ALSO A PORTAL SECTION AT THE BACK OF THE BOOK, WHERE
YOU CAN FIND LINKS TO GO TO MORE PERSONAL SITES AROUND THE WORLD.

AND ONE THING IS CERTAINLY TRUE. BY THE TIME THIS BOOK IS PUBLISHED, ALMOST NOTHING
IN IT WILL BE UP-TO-DATE. BECAUSE IT IS SO IMMEDIATE AND NETWORKED, THE PERSONAL
SITE WORLD MOVES QUICKLY, AND ENTIRE STYLISTIC REVOLUTIONS CAN TAKE PLACE IN A
MATTER OF MONTHS. SITES CAN CHANGE RADICALLY, AND BY THE RULES OF THE GAME

EMOTIONAL

SITES THAT TRAFFIC IN EMOTIONS ARE AS COMMON AS THEY ARE COMMONPLACE. THEY USUALLY DEAL WITH TOPICS LIKE LOST LOVE, HATRED, SADNESS, DESPAIR, DESOLATION, LONELINESS, ALIENATION, AND MELANCHOLY. AND WHEN THEY TAKE A BREAK FROM ALL THAT, THEY FOCUS ON DEPRESSION.

BUT NOT ALWAYS. IF YOU'RE THE KIND OF PERSON WHO CAN AVOID THE FIRST THOUGHT THAT COMES INTO YOUR MIND, AS WELL AS THE SECOND, THERE ARE ADVANTAGES TO BUILDING A SITE BASED ON YOUR EMOTIONS. YOU'LL HAVE SOMETHING TO SAY, YOU'LL BE PASSIONATE ABOUT IT, AND YOU WON'T SACRIFICE YOUR MESSAGE TO YOUR STYLE.

EMOTIONAL SITES TEND TO COME FROM ARTISTS WITH A STRONG INTEREST IN TYPE AND PHOTOGRAPHY. SOME, LIKE JIMMY CHEN AND IRENE CHAN, USE THEIR PERSONAL PROJECTS TO WORK OUT THE IDEAS ON FEELINGS AND RELATIONSHIPS, WHILE OTHERS, LIKE NIKO STUMPO, TRY TO TRANSPORT THEIR AUDIENCE INTO DIFFERENT EMOTIONAL STATES.

IN GENERAL, EMOTIONAL SITE BUILDERS INVEST A HUGE AMOUNT OF TIME IN THEIR PERSONAL WORK. THEY PUBLISH ON LONG, OPEN-ENDED SCHEDULES THAT REFLECT THEIR COMMITMENT TO GETTING THINGS RIGHT. BUT IN THE END, THE WORK USUALLY PAYS OFF, AND THE SITES

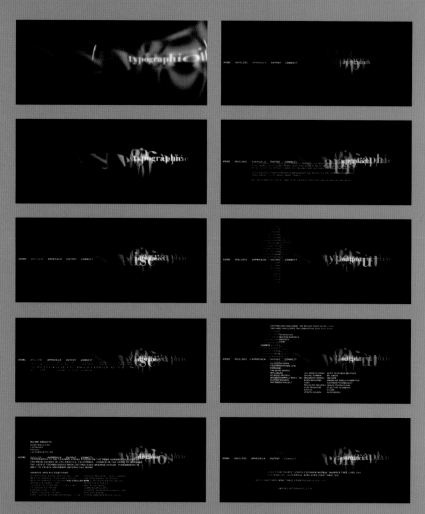

/LEFT

This version of Typographic was surprising in its overall consistency. It was done merely as a quick experiment to demonstrate the possibility of combining Flash with the desktop animation tool, After Effects. The wild distortions of the type have since appeared in several commercial sites that Chen has created for entertainment clients.

/OPPOSITE

This splash page for Typographic demonstrates how Chen separates business from pleasure. The imagery comes mainly from the artistic portion of the site. Since Typographic also serves as Chen's freelance homepage, he includes links to a portfolio section and contact information as well.

/INTRODUCTION

Typographic is the personal site of Los Angeles designer Jimmy Chen and is an excellent example of how to develop a signature style and employ it in continually inventive ways. Mostly, the site tries to express emotions through letterforms. They glide intricately into the picture. They are sweet, angry, embarrassed, and sometimes torn apart. They converge on ideas, linger, and then fade away. At other times, they hide behind mists and contradict themselves. But however they come and go, they always look like Typographic, and nothing on the Net looks anything like them.

SOUND ON

music by shawn strub

N E W S
COLD PACIFIC STORM HITS COCHRAN AVENUE, HUNDREDS OF WET DOGS.
POWER CRISIS PREVENTED OPERATION OF HAIR DRYERS.
WET PAVEMENT CAUSED FATAL FALL.

E N T E R

GRATUITOUS ANIMATIONS. MEANINGLESS CONTENT
TYPOGRAPHIC, TESTED BY APES, APPROVED BY MONKEYS

SOMETIMES WE DO SOME WORK

MAYBE SOME PRESS WILL HELP

PREVIOUS VERSIONS
ONE :: TWO :: THREE

WORK STUFF

EMAIL

THIS SITE IS OPTIMIZED FOR NETSCAPE 7.2.
REQUIRES T9 CONNECTION

A freelance designer living in Los Angeles, Chen came to the Web in a roundabout way. Born in Taiwan, he grew up in Greer, South Carolina, a suburb of Greenville. There, he developed a lifelong addiction to television and, strangely enough, benefited from it. At the time, television was going through a revolution. Thanks to newly developed digital tools, broadcast designers were learning to scale type, rotate it, and toss it around the screen.

"If you look at television graphics, you can see where Typographic comes from," Chen says.

After getting a design degree at Cal Poly/Pomona, Chen found a job working for an HMO, putting documents into Word templates. In those days, he developed the habit of doing his best work for himself. After hours of drudgery, he'd come home and create wild fonts and layouts that were never used.

Soon, he was playing with the Web and specifically, with flat JPEG pages with distressed type. It was these experiments that got him a job with Web firm eLogic. By then, it was 1996, and the entertainment community in Los Angeles was starved for presentable sites. Anyone with talent ended up working for movie studios, record companies, and the like. Chen was no exception. Soon he had big-name clients and was gaining recognition as one of the Web's top young designers.

By the time he moved north for a short stint at Studio Archetype, he had begun to experiment with TV-style animation for the Web. He built them into a site called Typographic, which was an almost immediate success, and secured for Chen an immediate place in the small club of well-known Web designers. Soon, he launched Typographic as an independent business, and kept the site as a constantly evolving essay on motion graphics and the Web.

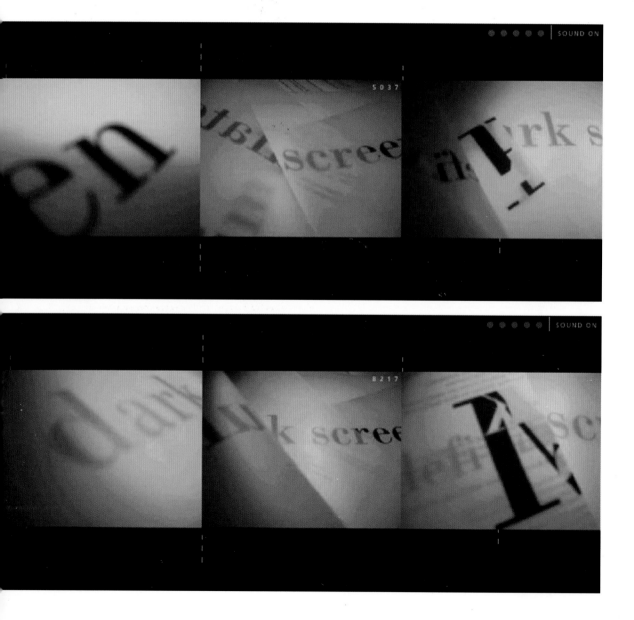

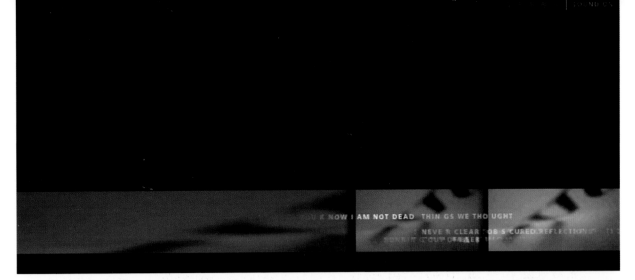

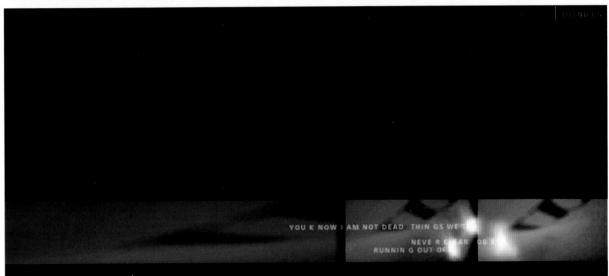

/ABOVE

Against a background that reappears in several sections of the site, Chen has created a slowly evolving poem. Here is an excellent place to see the kind of hide-and-seek games that he plays with text. Pieces of the sentences fade in and out with puffs of smoke. Spaces are placed in the middle of words to trick a would-be reader ("things" is rendered as "thin gs"). In the end, he has a laugh at the expense of his viewers, by letting them read one phrase clearly. It says, "No hidden messages."

/OPPOSITE

These images show just how far Chen will take typographic experimentation. Here, he took a piece of semi-transparent vellum and printed some words on it. Then, he placed the paper in front of a light and photographed it at different angles. Later, he animated it in Flash.

Technically speaking, television graphics are the stylistic inspiration for Typographic, but they certainly don't influence its content. Typographic belongs to the genre of communicative personal work. Chen sees his viewers as a captive audience, and attempts to speak to their emotions. He has messages to convey, and he reveals these according to how comfortable he feels with them.

And he has every reason to feel uncomfortable with the kinds of things he puts on Typographic. Psychologically, the site plays Dr. Jekyll to his usual Mr. Hyde. As a person, Chen is not one to pour his heart out after the funeral of the neighbor's poodle's cat. He has a reputation as a party-goer, a guy who likes his nights long and his times good. Crying on other people's shoulders is not part of his resume. For that kind of thing, he likes to use Typographic.

When he sits down to work on the site, he doesn't start out with any preconceived ideas. "Some people say design is a process of brainstorming," he says, "but I don't think there's any actual thought that goes into it. I don't see why people walk around with notepads and sketch out ideas. I believe in spontaneous creativity."

His ideas actually grow out of a kind of play. He opens a canvas in Photoshop, types out a few letters, opens a few layers and starts to see what happens. Words, colors, and thoughts get thrown down; images are pulled in. All the while, the process turns increasingly inward, and thoughts start to emerge. What is he feeling that day? Is something bothering him? Does he have something he wants to tell someone but can't? Sometimes, nothing much emerges, but often Chen will focus on an idea that he really wants to get out.

"If I've got a feeling," he says, "I put it online to get it over with. For me, during that time, I'm my only audience. Sometimes the site becomes closure for me."

Although it is sometimes difficult to figure out the exact meaning of what's written on the site, the story behind the words will usually be real and specific. "On the site, I'm always saying something to someone," he says. "I know who it is, but nobody else realizes I'm talking to anyone in particular. It could relate to a relationship I'm in, or something like that. When other people read the words, they could mean anything, but to me they're specific."

To avoid the difficulties that might arise if people knew exactly what he was talking about, Chen keeps the messages in Typographic vague. Even his close friends, and sometimes the very people he's "talking" to, don't know exactly what he's saying. "I did a piece about someone and then showed it to her," he says. "She liked it, but she didn't get that it was about her."

This game of hide-and-seek lies at the root of Typographic and keeps it from being merely a series of pretty pictures. There's a kind of orphaned meaning in every piece. Behind it all, some real thing exists, but you never know quite what it is. Even so, an emotional urgency still infects the site and gives it its peculiar force.

/OPPOSITE AND ABOVE

This animation is more image-heavy than usual for Typographic. It transposes a moving subway car against the view down a dashed yellow line. Its text deals with directions, but on the whole, it serves as the kind of motion experiment that few clients would ever want or need.

/TECHNIQUE

Chen often describes his methodology in humorous terms. "Open Photoshop," he once said, "animate in Flash, you're done." At another time he described his process as: "You do this, you do that, you put this into that, it's done."

For all this rhetoric, don't expect anything but meticulous care from the site. Chen may not have much regard for methodology, but he firmly believes in personal work as a place to experiment with new ideas. For him, that means taking hold of whatever tools are at hand and using them to create something. And it's easy to see that he puts an enormous amount of work into the site. To get a single frame of an animation, he may build a three-dimensional letterform in Illustrator, add effects in Photoshop and then animate it in Flash. It will be joined by dozens of other letters, similarly built, and each animated on its own timeline.

Probably it's this dedication that keeps the site looking so unique. Typographic pioneered the Web's use of After Effects, a broadcast animation and composition tool. At one point, it was the only site that had letters that dissolved into mists. Chen also wraps sentences around three-dimensional cylinders, flips fonts over and uses them backwards, and even photographs sentences printed out on semi-transparent vellum.

"I try to keep the integrity of design," he says, "and explore different ways of doing the same thing. It's a place to learn to work in an application and integrate other applications in a new way."

One thing that's not a part of the equation is something you might expect—a lot of different typefaces. In spite of the site's name, its three-font package (Bodoni, Gill Sans, and Frutiger) has never changed. Chen maintains that a set of fonts like this one is all you need on the Net: Bodoni is a serif, Gill Sans a wide sans-serif, and Frutiger a more compact one. "I don't think wacky typefaces work with the Web," he says. "Type that's bland fits anything if you've got the right colors. And plus, the more you use a typeface, the more you know about it."

But overall, it's simply his eye for multiple animations and his feeling for the tools he's using that separates his work from the ordinary. "I look at it," says Shawn Johnson, his friend and the Creative Director of Bleu 22 Studios, "and sometimes I think, it's amazing, but who would want to do all that?"

Like many designers, Chen has a love/hate relationship with his site. When he began, he expected little out of it and was merely trying to express a few feelings and experiment with a new medium. Nowadays, he has found himself uncomfortable making something that so many eyes will follow.

"I am aware of people looking at the site," he says, "and I think twice about people looking at the messages. And that's why I keep hiding messages now. If you can see it, that's great, if not, then hopefully you've enjoyed the animation."

Not surprisingly, Typographic's future is uncertain. Chen often threatens to close it down altogether and open a new, anonymous site. That way, he says, he could return to the clearer and stronger messages he used to put up. But it is hard to imagine a better name and platform for his style of work.

/OPPOSITE AND BELOW

This section, called "visualize," shows the kind of broadcast graphics tricks that Chen strives to bring to the Web. The images are distended close-ups of photographs, and they are overlaid with startling text animations. These include masks, starbursts, and particle disintegration.

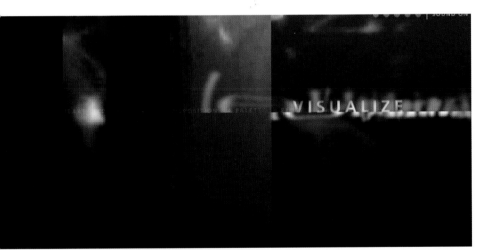

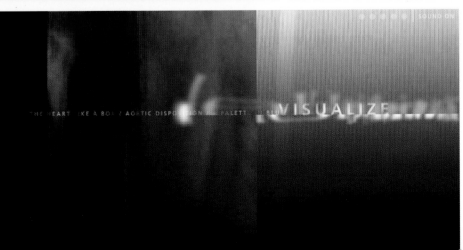

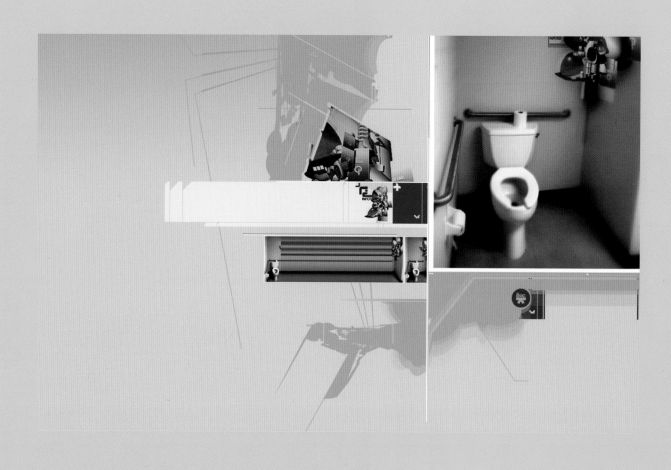

/INTRODUCTION

Hallucinations are normally only interesting to the people having them, but in recent months, the grim visions of Mike Young have struck a chord in the Web community. With companies folding and thousands losing their jobs, designers have learned to love his warped furniture, torn-apart faces, and buildings filled with toxic waste.

Young works this dark magic on two personal projects, Designgraphik and Submethod. Though technologically simple, they derive their force from his peculiar personality and dim way of seeing the world.

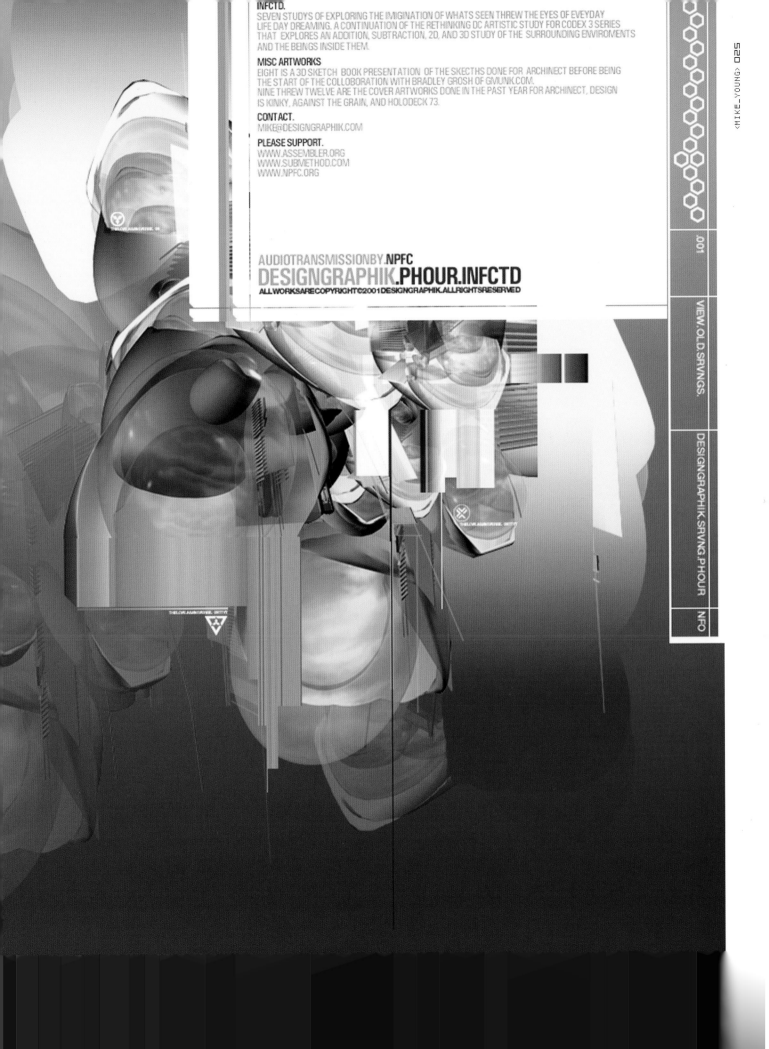

INFCTD.
SEVEN STUDYS OF EXPLORING THE IMIGINATION OF WHATS SEEN THREW THE EYES OF EVEYDAY
LIFE DAY DREAMING. A CONTINUATION OF THE RETHINKING DC ARTISTIC STUDY FOR CODEX 3 SERIES
THAT EXPLORES AN ADDITION, SUBTRACTION, 2D, AND 3D STUDY OF THE SURROUNDING ENVIROMENTS
AND THE BEINGS INSIDE THEM.

MISC ARTWORKS
EIGHT IS A 3D SKETCH BOOK PRESENTATION OF THE SKECTHS DONE FOR ARCHINECT BEFORE BEING
THE START OF THE COLLOBORATION WITH BRADLEY GROSH OF GMUNK.COM.
NINE THREW TWELVE ARE THE COVER ARTWORKS DONE IN THE PAST YEAR FOR ARCHINECT, DESIGN
IS KINKY, AGAINST THE GRAIN, AND HOLODECK 73.

CONTACT.
MIKE@DESIGNGRAPHIK.COM

PLEASE SUPPORT.
WWW.ASSEMBLER.ORG
WWW.SUBMETHOD.COM
WWW.NPFC.ORG

AUDIOTRANSMISSIONBY.**NPFC**
DESIGNGRAPHIK**.PHOUR.INFCTD**

INFCTD.
SEVEN STUDYS OF EXPLORING THE IMIGINATION OF WHATS SEEN THREW THE EYES OF EVEYDAY
LIFE DAY DREAMING. A CONTINUATION OF THE RETHINKING DC ARTISTIC STUDY FOR CODEX 3 SERIES
THAT EXPLORES AN ADDITION, SUBTRACTION, 2D, AND 3D STUDY OF THE SURROUNDING ENVIROMENTS
AND THE BEINGS INSIDE THEM.

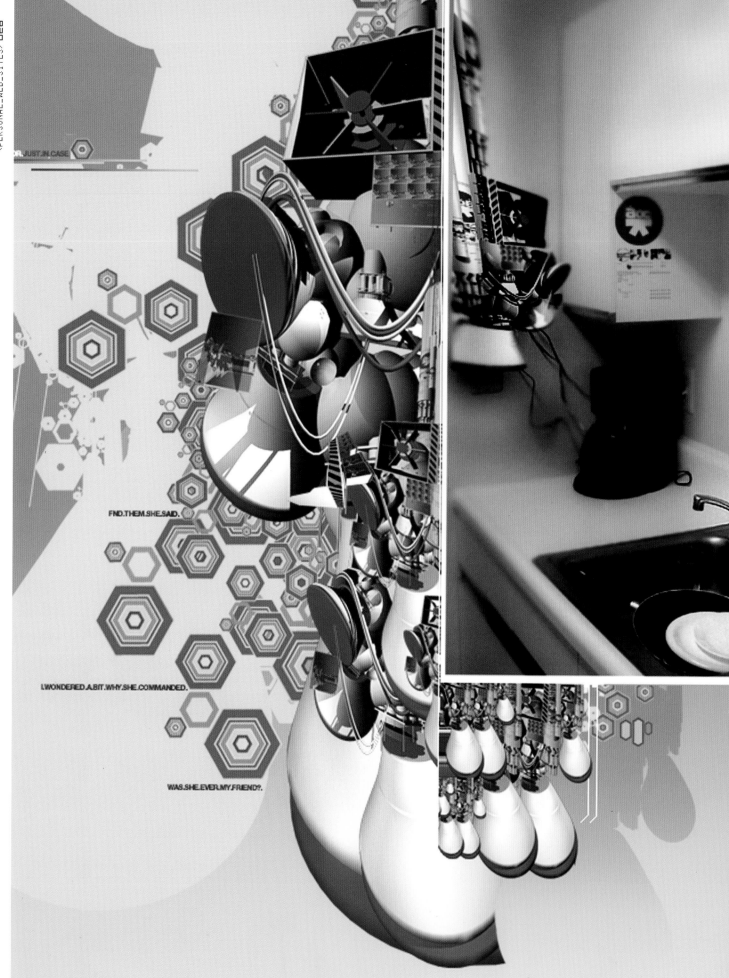

OR.JUST.IN.CASE.

FIND.THEM.SHE.SAID.

I.WONDERED.A.BIT.WHY.SHE.COMMANDED.

WAS.SHE.EVER.MY.FRIEND?.

Mike Young waltzed on to the scene several years ago when he built the corporate site for Vir2l, a Web design firm based in Washington, D.C. More a personal project than a professional one, its splatter of three-dimensional shapes won every award in the book, including Clios and Cyber-Lions.

But like many things that have happened over the last seven years, Young's ascent was a bit of a surprise. He didn't go to a "big five" design school or drop in after a long tenure at an ad agency. He came from sleepy Knoxville, Tennessee, and had fostered his cluttered style at Roane State Community College and the Minneapolis College of Art and Design.

Throughout school, Young had been trained as a computer artist, but when he graduated, he knew enough about Web design to put up a portfolio site. Surprisingly enough, it won him a job at Vir2l, a firm built on the idea of turning raw recruits into top Web designers.

Vir2l turned out to be an excellent place for Young. Back then, he had few real design skills and almost no knowledge of things like typography. But he had been an artist for a while, and that helped him fit in with the rest of the Vir2l crew, most of whom were involved in their own personal work. He found a special friend in James Widegren, who runs the Web design portal Threeoh. Widegren was about as different from the Tennesean Young as can be imagined: a black-clad, cosmopolitan Swede who rarely let a hair or letterform fly out of place. He gently prodded his colleague to be more careful about his designs, and Young returned the favor. "I learned a lot from him," he admits.

In time his design became more restrained, and he went on to earn a decent professional reputation working for clients like Mercury, DC Shoes, and MacUser. Meanwhile, he began to build an ambitious pair of personal Web sites. The first is Designgraphik, his world of stressed typefaces and redesigned environments. The other is Submethod, on which he collaborates with writer Stanley Wolukau-Wanambwa and musicians NPFC.

Currently, Young freelances for the entertainment industry and, like most personal site designers, has few other hobbies to speak of.

/BELOW
..

The theme of the 4.0 version of Designgraphik, Infctd, becomes clear in these images. The cylinders that hang threateningly over the stove lie somewhere between the mechanical and the organic, and are a good example of Young's hallucinatory style.

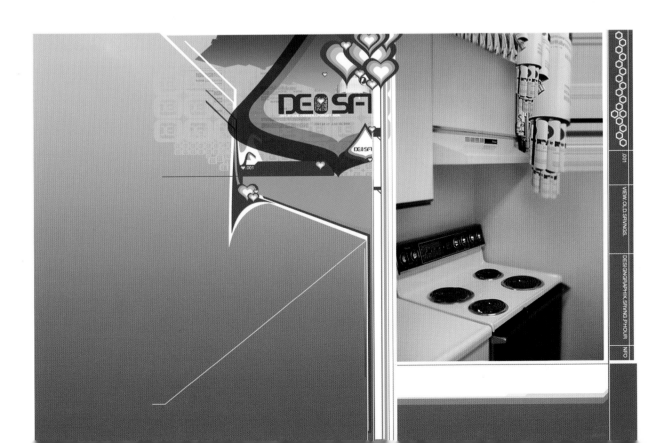

Young is the kind of designer you'd rather not see the kids out trying to imitate. His layouts are complex and cluttered. He repeats elements of his designs shamelessly, and sometimes uses colors that would normally be better mixed with others.

Even so, his style is not completely random, nor is it even unique to him. It was developed with other designers at Vir2l like James Widegren, Bradley Grosch, and Anders Schroeder. Over the course of a year of long nights and late pizza deliveries, they came up with a style based on Illustrator to create three-dimensional objects. "It was a competition almost every hour there," says Young, "everyone would build on each other and try to keep up with each other."

They learned to make wild shapes with odd perspectives and blobs of liquid that grew organically across the canvas. The style is easy enough to imitate, but tough to do well. The trick, as far as Young is concerned, is to make sure the frenetic and haphazard layouts still have an underlying structure.

To do this, he advocates starting out carefully and stringently. He normally spends a lot of time building a piece out, moving every point along a grid and making sure the type and images are properly aligned. At this point, the work is probably still too clean. So Young starts grabbing points and pieces of the work and pulls them around the canvas. While keeping the overall structure of the piece, he adds many new elements, and distorts old ones. The cleanliness soon flies out the window, but the piece becomes more interesting as a result.

"Whenever I work," he says, "I always go back and do much more than when I started. I feel awkward if I keep stuff clean. I know it's not me."

In approaching his personal Web sites, Young doesn't always keep with the same schedule or process. Designgraphik is by far his most deliberate project. It normally takes him about two months to build a version of the site. He usually plots it all out first, and then slowly makes each piece over a six-week period. After that, he drops it and lets it lie fallow for a bit. When he returns, he has fresh perspective on it, and often adds to and messes up his original design.

With Submethod, Young has to make allowances for his collaborators, and things tend to move more quickly. Normally, the team works by handing off pieces to each other. If NPFC comes up with a bit of music, Young makes a design just for it. Occasionally, they work backwards, or with writing as the base. As a result, the site is a good deal less wild than Designgraphik. "It's a challenge not to go so ballistic," Young says wryly.

Technologically, Young's work has always been fairly primitive, and inspiring to those who hate the idea of learning too much about software. Even so, his creative processes are professional and more deliberate than many would guess. Together with his peculiar taste in content, they have bought him a good seat in the Web firmament.

/OPPOSITE, ABOVE

In its more abstract forms, Young's work leaves its subject behind. In this environmental treatment, the original inspiration has been completely subsumed in the design.

/OPPOSITE, BELOW

The inspiration for the piece came from the fact that Young hardly ever saw this programmer except from behind. The graphic is a good example of how Young likes to present people as he "sees them."

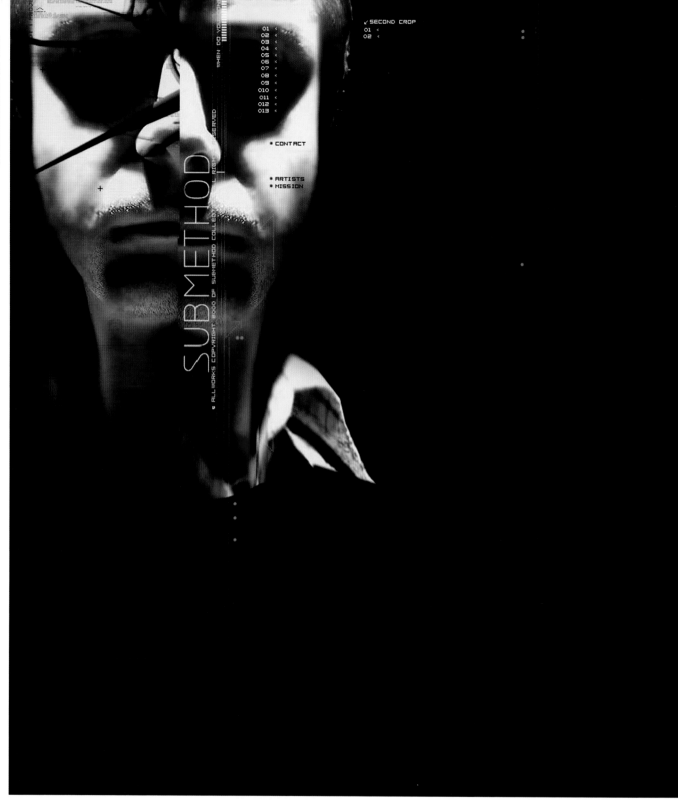

SUBMETHOD

WHEN DO YOU

01 <
02 <
03 <
04 <
05 <
06 <
07 <
08 <
09 <
010 <
011 <
012 <
013 <

SECOND CROP
01 <
02 <

• CONTACT

• ARTISTS
• MISSION

/THE FUTURE

You probably can't write a recipe book for a successful personal site. You can only describe matters up to the point where the artist leaps off into whatever it is that makes him or her unique. With Young, it's clear that he's doing exactly what he wants, and that drives him to spend the huge amounts of time, effort, and planning that his work requires.

As he moves deeper into the freelance world, Young will probably have to do something more commercial with Designgraphik, and he hopes to broaden out Submethod. Like most personal site designers, he's not sitting still and has no plans to give up soon.

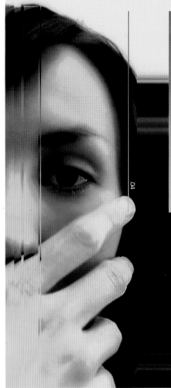

/ABOVE

Here, Young compresses another friend's face, and crisscrosses it with bars of colors. The two halves of the photo have different scales and positions, making an intriguing image.

/BELOW

This image could be a study of how to hide faces in a layout. Whether obscured or covered, they highlight Young's dislike of showing things as they usually are seen.

/OPPOSITE

This Submethod image shows clearly the kind of manipulation Young prefers when dealing with people. This offsetting of the two halves of the person's face is unique to Young.

/ABOVE

Stumpo likes to use small images of people set on a wide open canvas. For this piece about imagination, the contrast between the tiny portrait and large layout manages to capture the elation that creativity brings to its young subject.

/OPPOSITE

This piece presents a collage of different elements, including painted canvases and photographs. Its surprising color palette and sweeping black lines give it a power rarely seen on the Net. Even so, it retains its focus: a photograph of a girl, who somehow manages to be the central element of the design, even though she takes up less space than the type that identifies her.

/INTRODUCTION

When applied to Nicola Stumpo, "originality" is a word that rarely comes with the phrase "lacking in" before it. It wasn't always so. In the early part of his career, the Milan-based designer built whimsical animations that reminded everybody of someone else. Now Stumpo has come into his own and can call his sliding black masks and frenetic graphics all his own.

With ABC, or "Abnormal Behavior Child," his goal is to produce emotional reactions in his viewers. Whether he succeeds depends on whom you ask, but the intent makes ABC one of the more forceful sites around. If Stumpo decides he wants his animations bright, they will be the brightest, happiest things around; and if he tries for dark, nobody will mistake them for anything else. And that's why ABC deserves a closer look.

GIRL

GIRL

TING

ABNORMALBEHAVIORCHILD

/BACKGROUND

Stumpo is another one of those kids with more energy than he knows what to do with. His days start early and end late, and, like many in the first generation of Web designers, he has no patience for being patient.

His dedication to the Web is a bit of a surprise. Almost everyone who builds personal sites on the Net—whatever his or her pretensions—is professionally a Web designer. Stumpo rarely, if ever, gets paid for work on the Web, and then only in special fields like Flash music videos and screen savers. But even though he has no formal design training and makes his living doing motion graphics for MTV Italy, he considers personal sites the very thing he was put on the Italian peninsula to do.

Some time before the advent of the Web, Stumpo was born in Norway and raised in Rome. From an early age, he had an interest in motion, albeit of a physical sort. From sixteen to twenty, he toured Europe as a pro skateboarder, using the money to pay for art school.

Thanks to a knee injury, that career came to a close and Stumpo returned to school, where he finally came into contact with the Web. It was love at first sight. "That," he said to himself, "is exactly what I want to do." Immediately, the young artist sold several of his paintings, bought a computer, and took a job at an advertising agency in Milan.

When he began with personal work, Stumpo tried hard to imitate star Web designers, like Matt Owens. But after absorbing criticism for it, he's made contrarianism the touchstone of his production. "Now, when I think I'm doing one thing too much," he says, "I do the opposite."

Stumpo's main personal site is ABC, or Abnormal Behavior Child. Recently, he has won international recognition for its frenetic, wide-screen animations and unique characters and stories.

/ABOVE
...

These images come from the main sections of "Destroy Everything," a darker issue of ABC. It featured large layouts dominated by black, along with bright moments of frenetic movements. The site sought to build frustration in its visitors, especially with its difficult navigation and tendency to flash beautiful images too quickly for people to enjoy them.

/OPPOSITE
...

This is actually a combination of three-dimensional objects with a sliced and manipulated two-dimensional background. Careful investigation reveals illustrated faces, photographed dolls, and other curious elements.

/CONTENT

"Ninety percent of the Web is cold," says Stumpo. "It's just nice images. The main problem is that the designers don't have an idea; they just play around until they get something that looks cool."

ABC does have a clear idea, and, like that of many successful personal projects, it has to do with emotions. But by contrast to a site like Typographic, which tries to explain certain feelings, ABC tries to produce them. "I want to tell stories where each part connects its viewer with an emotion," he says.

Stumpo knows that reaching out from the screen and placing ideas in the heart of a viewer is not easy, especially given the sloth of the average Internet connection. And early on, he admits he failed. "I had an idea in my mind," he says, "and I thought others would immediately pick it up and feel exactly what I was feeling. But it didn't work."

The problem, he felt, was that he was being too cryptic. The messages were too hidden, the ideas too vague. And worst of all, he was assuming that everyone would immediately pick up on the nuances of his emotional life. Like many Web designers, Stumpo didn't realize that while he was spending a huge amount of time in front of his computer, and the rest of the world wasn't sitting there next to him.

He improved things a great deal by making them more simple and obvious. One of his more effective pieces showed a girl licking a Popsicle on a bright summer day. The photo captured the idea of heat (the Popsicle was melting) and the idea that something sweet and cold would be perfect at a time like that. Masks slid around, revealing a green field, and somewhere on the outside of the animation, a bee buzzed. It hit you over the head with happiness and contentment.

This simplicity and boldness accounts for a lot of the variety in ABC. Stumpo works with different kinds of emotions, so he uses varied graphics. His "Magick Garden," for example, consisted of lazy animations. Characters enjoyed their ice cream in a playground of toys and listened to music fit for a yoga class. By contrast, his "Destroy Everything" issue was dark.

Newer versions of the site are more interactive, asking users to add pictures to the mix or to change the environment. "I want it to be a real interactive story," says Stumpo, "where peopled have to get involved with it." There, he hopes, the participation of the user will allow him to reach people more intimately. ABC will always have a boldness that sets it apart, and a content that keeps people guessing and moving. And with luck, it will keep them entertained too.

Stumpo's method of working has nothing to with planning, though it has much to do with experimentation. "As soon as you make a storyboard," he says, "you lose all your inspiration." In working on ABC, he tends to design something first and then run ahead of himself. He plows along, hitting the "Save As" button frequently, and ending up with many variants and riffs on the same theme. Then he goes back later and opens them all up and picks the one he likes best.

He works at least a bit on ABC every day, even if it's simply a matter of drawing for a few minutes in a sketchbook. More usually, he spends hours on it, bringing in elements, trying them out or consulting with a programmer. A single version of the site takes months to complete, even though it may take only a few minutes to explore.

In addition to his work ethic, like most good personal site designers, Stumpo also brings a slightly odd skill set to the table. Most people who know him tend to forget that Stumpo professionally does motion graphics and also paints canvases that people don't mind buying. He brings both of these talents into ABC. Its motion is carefully controlled, depending on the effects he's looking for. He uses slow-moving masks to play hide-and-seek on happy sites, but turns to hyperactive movement when the emotion is more intense. In one scene of Destroy Everything, he even used a beautiful and intricate image to convey angst-ridden frustration. He pulled the trick by off flashing the image too quickly for it to be digested and enjoyed by its viewers.

Less noticeable on the site, but growing in importance, is Stumpo's painting. These days, many of its environments are first done on canvas and then scanned into a computer. This gives his site many of the more complex tones and textures that appear in the work.

On the macro level, Stumpo has benefited from inexpensive database technology. In order to produce a greater emotional collusion with his visitors, he's now allowing them to upload their own graphics and photos. These are added to the animation and form a customizable part of the design. It's a kind of cooperative experience that Stumpo believes will bring his users more intimately into the process, allowing him to more effectively shape their reactions.

By far the most important part of Stumpo's work is the moment of closure. Many designers create art pieces and are never satisfied with them, and making a successful personal site means building a complete story out of all the graphical play that goes into it. For Stumpo, this process is simple. "I do everything for myself first," he says. "If I love it, then I know I can publish it. Otherwise not."

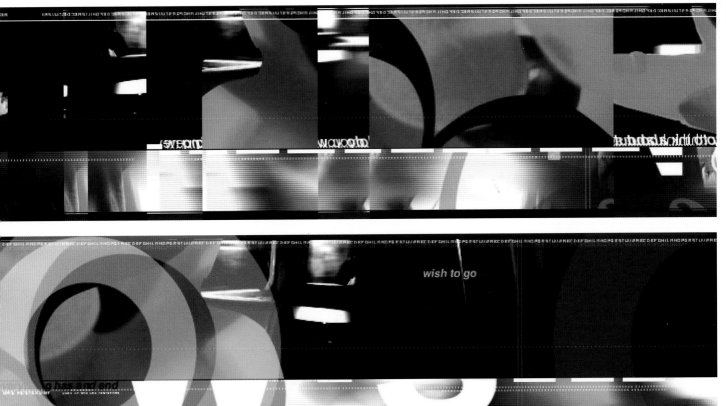

/FUTURE

High-impact content, multiple materials, and frenetic motion are all things Stumpo hopes to use in efforts to produce online emotions. In the future, he hopes to turn ABC into a narrative platform. The stories should feature multiple entry points but produce emotions around particular themes.

ABC should remain one of the more stable personal projects on the Net. Stumpo is an artist, and the site is his main outlet for his work. The only question is really whether the rest of the artistic world will ever see what the online community already has.

/ABOVE

From an early version of Stumpo's site, these images give some idea of the complex motion graphics that form such a large part of his work. The movement in his animations tends to run along a horizontal axis, with different elements and frames sliding across and on top of one another.

/OPPOSITE

From the happy side of Stumpo's work comes this piece from ABC's "Magick Garden" issue. The summery colors and bright stars are complemented by pictures of a girl eating an extremely inviting Popsicle during a day in the park.

/INTRODUCTION

Probably the least attractive thing about the personal site world is its fraternity house atmosphere. It may be full of all types, but the loudest and most aggressive are the "Web Boys," a group of young males who work all the time and comment on everything in a slang derived from the American hip-hop vernacular (which sounds indescribably bizarre when mixed with the English taught to school children in Denmark).

Among them, Irene Chan must feel like an alien. A quiet, normal person with a quiet, normal life, she has never been known to employ hip-hop vernacular even in moments of extreme danger. And because she designs so carefully, and because she never likes to publish without saying something, her Eneri.net has a far slower update schedule than most. But, as a result, it's a rarely unified and beautiful site well worth a visit.

/BACKGROUND

Admittedly, Irene Chan is an unlikely artist, and she may end up not being one. She was born and raised in Hong Kong, where she was only dimly aware that you could even make a living as a designer. But growing up, she was a huge fan of Japanese anime and dreamed of some day drawing her own cartoons.

She went to school in the United States in the quaint southern town of Savannah, Georgia. There, her Hong Kong life slowed down, and she charted a career for herself as a designer. She got a job right after graduation and has since worked professionally for large firms, building what marketing people have christened Internet solutions, and the rest of the world calls Web sites.

It is a job many personal site artists would run from in terror, but Chan seems comfortable in both worlds. When she first started surfing around the Web, she came into contact with the work of David Yu on DHKY. She became interested in Yu's mingling of modern design and Chinese culture, and he in turn, encouraged her to put up her own playground.

The result was Eneri.net, whose first issue featured Chinese characters animated in front of lush photography. Its conceptual unity and sheer beauty secured her a place in the personal site world, something she has only accepted because she can't do anything else about it.

Chan now lives in the Bay Area, where she continues to put most of her work into her career and to play with Eneri on the side.

/CONTENT

The personal site world is built on an odd paradox. Anyone with a modem can look at what you do, but if you like, you can also remain anonymous. In fact, there are many well-known projects made by people who don't reveal their identities, or prefer to hide behind an e-mail address. And Chan is very much like them.

"Eneri was a project I wanted to do for myself," she says. "I didn't think about it that much, or I didn't care because I didn't have my name on it."

Looking into the site, you can see that her desire for anonymity doesn't end at the URL. It is generally built around photographs of people, but in them the camera tends to hide as much as it reveals. The subjects normally look away from the lens, or have their faces obscured behind flowers or other elements in the design. Even frontal shots, like those of Chan herself, are often blurred or out of focus.

Her use of type and language is similar. The site's ideas are expressed mainly in wildly warped (and ultimately illegible) English or animated Chinese characters. Of course, writing in Chinese does not exactly hide your message—a mere billion people can read it— but in the personal site world, it's only slightly more common than Hittite. Most of the designers meet and greet in English and even those who don't speak it often get someone else to write their text for them. But for Chan, such a choice helps to create distance from her audience even as it doesn't completely hide her message.

/OPPOSITE

Faces obscured, these figures are classic Eneri—shy, retiring and yet somehow possessed of a beauty that overwhelms the design. This issue, titled Confusion, expresses, among other things, the hope that the world would somehow forget Eneri.

For there are, of course, messages in the site and deeply personal ones at that. In its first version, for example, the text consisted of scraps of essays and poems that she had written into a journal. They came from different places, but when she put them together, they told the story of a woman who spent every day in the company of someone she loved, but could just not bring herself to tell the person. Of course, this is a common experience (what girl doesn't go through at least part of her student days analyzing the daily habits of some pimpled Adonis for signs of true love?), but it serves as a neat summation of the tensions in the site. One could easily imagine that the person was Chan herself, and that her own discomfort with self-revelation is at war with her need to express herself.

Together, the different elements of the site all point toward and draw strength from this single emotional gesture, this contradictory desire for privacy and self-expression. To have such a single clarity of thought, purpose, and execution is rare, and ultimately gives the site a force that's allowed it to weather time and scrutiny better than most.

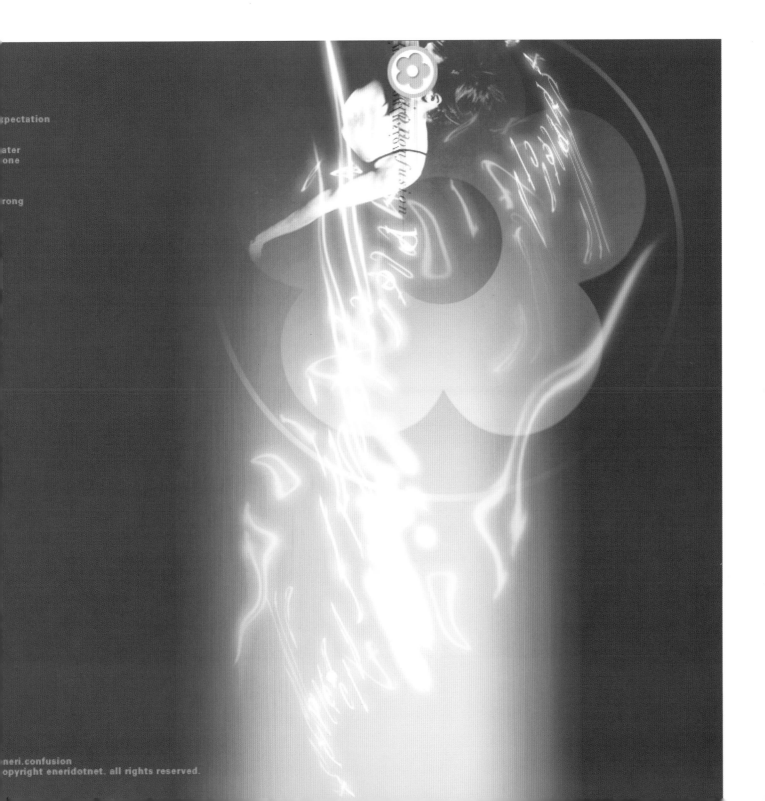

/TECHNIQUE

Because a discussion of technique usually relies on a set of practices established over time, it's also a bit risky to wax philosophic on the subject with Eneri. However, there is a backbone to what Chan is doing, a push for coherence that overrides everything else. "For me," she says, "it's difficult to have something to say and to have the imagery to make it meaningful."

Naturally, she spends a good deal of time thinking about what it is that she has to say. For subject matter, she tends to rely on reading that goes outside the usual design corpus, including books on the dynamics of relationships between men and women, and between people and themselves. Most often she picks a theme that resonates deeply with her, which is important since much of what will follow is a painful trial and error process to get things right.

Her work begins in a static program like Photoshop and often doesn't leave it. And though she doesn't mind planning things out, and she tends to stick with her original idea, she is quite free about how she goes about getting her ideas to work on the screen. Each image results from a lot of back-and-forth checking to make sure the text, photos and animation all come together. "Sometimes after I go to the animation," she says, "the design doesn't work, and I'll have to go back to change the pieces."

Needless to say, she finds it difficult to finally publish the site. "The first version was pretty easy to do," she says, "I didn't have all this pressure from other people, but now it's more of a stress. I don't want to do something that means less."

But one of the happier consequences of this is that she will hardly ever publish something unless she is absolutely satisfied with it. It doesn't matter if she waits on a piece for a year before she decides whether or not to put something up on the site, and she often does.

These days, she has greatly restricted a lot her use of animation, but she still relies heavily on the lush, bright photos and images that always made her site a kick. Eneri will probably never be one of those sites that is updated every day, but when you do get an update, it's generally worth it.

/OPPOSITE, TOP
...
The tantalizing messages of this piece are rendered entirely in Chinese characters, with all faces, naturally, turned the other direction.

/BELOW
...
A blurred face doubled with its own negative forms the center of this image, a rare and revelatory one for Chan's site.

/OPPOSITE, BOTTOM
...
Though this interface doubled as a homepage for Chan, its main purpose was to show off experimental imagery, a category into which it also fell.

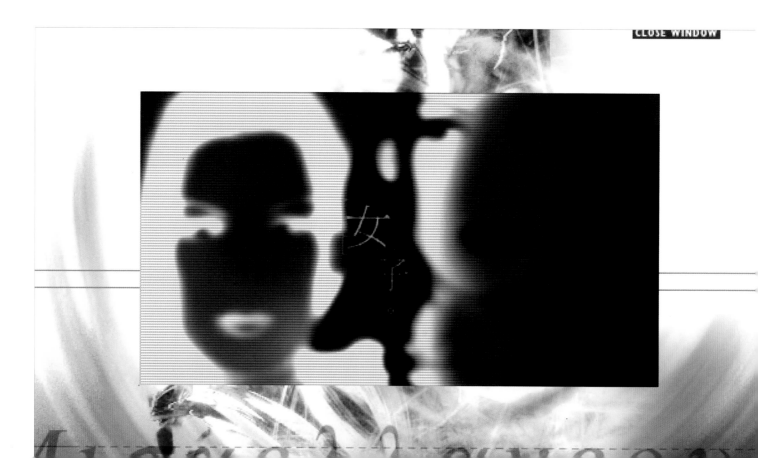

CLOSE WINDOW

It is clear that Irene Chan doesn't get much out of the personal site universe. She enjoys meeting people, but the part of it where angry designers flame her site is something she could live without. Her heroes come from traditional design, and she'd much rather be successful there.

"We're just these underground kids," she says, "We don't care about solutions."

So she updates her site only when she has something she feels she has to say, and she tends to think that every version of the site will be her last. Sooner or later, she says, she will sink down, and be forgotten. And in a world moving as fast as this one, that's no idle dream.

"the most painful distance in the world" - also appeared on atomicattack.com
special thanks to sifu at dhky.
click here to launch the eneriwomaninterface.

/ABOVE

This two-part series shows off the dreamy but flat illustration style of the site. As with almost everything on Hungry for Design, these pieces contain no scanned material.

/INTRODUCTION

In the quasi-war between print and Web, the soldiers fight on generational lines. The older folks who were raised on print never seem to get interactivity, while the younger ones rarely get typography. Somewhere in the middle lies Brazilian artist and designer Fernando Costa.

Costa's personal site is a perfect contradiction in terms. It's a print piece, except it lives on the Web. It's a painting, except it's done on a computer. It's completely off-the-wall, except it conforms to stringent design principles. Most of all, it's Hungry for Design, one of the odder personal Web sites on the Net.

/BACKGROUND

Fernando Costa comes from the third generation of an artistic family in Rio de Janeiro. His grandfather was a scenographer, his mother a sculptor, and his brother a graphic designer. From an early age, he was immersed in the latest trends in drawing, painting, and collage making. At fourteen, he split his first art show with his mother, and a few years later, had his own solo exhibition at Rio's respected Museo do Açude.

Even with a start like that, art can be a tough way to make a living, so Costa followed his brother into design school in Rio. There, he did well and found work at the well-known Spajera design firm. But after graduation, wanderlust set in and he lifted his sights to Atlanta, where he had once lived as an exchange student.

He landed a print job there and, since he didn't know too many people, filled up his spare time playing with the Web. After a while, he decided to put together a personal site, mainly to continue showing his art to his friends back in Rio. He called it Hungry for Design, but few people knew about it.

That all changed when he took a job with the WDDG, a then-hot Web firm in New York City. The company linked Hungry for Design from its homepage, and Costa was soon known around the world. Along the way, he got a crash course in Silicon Alley art ethics. He learned what it meant to toil all day at the office and then go home to your personal work. He learned that people could link to new versions of your site as soon as you could put them up. He also learned that they would complain loudly if they didn't like what they saw. "Nowadays," he says, "I'm under much more pressure, because I know so many people will look at what I do."

Eventually, Costa quit New York and went back to Atlanta. He still updates Hungry for Design regularly, and still refuses to compromise with it. Even today, it remains the same tough-to-navigate, barely interactive site it always was. And people still keep coming.

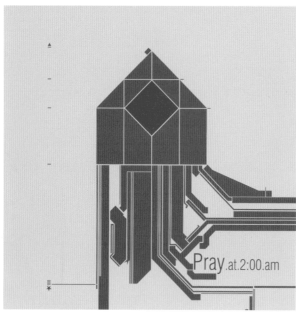

/TOP LEFT AND RIGHT

...

These images come from a series of color studies Costa made, in which he sought to develop a flat-colored, two-dimensional style that went against the heavily layered, photographic graphics that were more popular at the time.

/ABOVE, NEAR LEFT

...

Often Costa will use the site to mark down his feelings at a specific place and time. Apparently, 2 A.M. on whatever day this was seemed like a good time for Costa to get in touch with the man upstairs.

/ABOVE, NEAR RIGHT

...

This image reflects Costa's frustration with the world around him, and is a good example of how Costa likes to use the site to reflect himself, both stylistically and emotionally.

/CONTENT

Whatever words you use to describe Hungry for Design, avoid "intuitive." It's not. It can take forever to load and rarely has an interface, unless you count a painting that spills out of your browser window and has tiny hotspots for navigation. Getting through it can be painful.

But don't expect Costa to cry if you say you don't like it. He's heard it all before, and in his book, it's perfectly OK to have a lousy interface on your personal site, so long as that's what you want. "I don't do much for anyone else," he says, "That's why people complain so much about my navigation. They expect certain things, and they're not there."

So what exactly is there if you take the time to look for it? Something quite odd for the Web—a series of largely static pieces that mingle textbook design methods with Costa's own illustrations and collages.

In talking about the site, Costa makes a distinction between self-expressional and self-presentational art. In self-expressional art, he says, you take what's inside you—your thoughts, your plans, your feelings, your fear of charging hippopotamuses—and expose it to the outside. And while Hungry for Design does some of this, Costa hasn't made that the focus of the site. "For me," he says, "a personal site is a way to express yourself physically, like getting a haircut."

People, he knows, tend to build visual shells around themselves. They shave their heads and put on green glasses; they dress up like corpses; or they even wear suits and silk ties. The choices they make depend on the friends they have and the lives they lead. Similarly, Hungry for Design points out how Costa sees himself and his place in the design world. "It's usually something that happens to me that makes me to work on the site," he says, "It's not that I want to do something cool."

A new job or a breakup with a girlfriend might bring a black and moody design. A free trip to France would probably pull out the flowers and champagne. But mostly the site records long-term developments in Costa's feelings about his profession. When he was slaving away in New York, he drew a computer that had grown tentacles and enveloped the design firm he was working at. More recently, he staged a stylistic revolt against Silicon Alley itself, trading in New York's heavily layered, three-dimensional graphics for flat, brightly colored spreads.

It's probably most fun to move around the site and check out Costa's self-presentation at different moments in time. For this, Hungry for Design has a complete archive of everything he's done since the age of fourteen. You can find stick collages and paintings, Photoshop layouts and Flash movies, and whether you like the work or not, it's still interesting to follow Costa's artistic development and the emotional journeys he's taken along the way.

/BACKGROUND

Since Costa uses Hungry for Design to record his thoughts about himself and the world around him, he tends to work on it at moments of high emotion. He often begins with a feeling rather than an idea and lets it flow from there. "It's usually spontaneous," he says, "I don't have a process."

In doing a version of the site, he produces each image individually, as though nothing else were going to be seen around it. One piece does not depend on any other, and they proceed in no general direction or order. And since they are supposed to represent snapshots in time, once he's done, he never goes back and changes them.

Naturally, this makes his site one of the more chaotic you'll find, but it is not completely so. For all its freedom in subject matter and lack of forethought and planning, Hungry for Design does have rules, and it sticks to them. Some are quite common, like the usual grid and typographic conventions, but others are completely idiosyncratic.

First, there's the site's print fetish. Costa often produces his pieces as if they were posters and not JPEGS. He begins them as blank canvases in Photoshop or Illustrator, usually at very high resolutions, and sometimes even with a CMYK color scheme. This lets him pick his colors by value, and also gives his work a flatter and less fluorescent look than much of what is on the Web.

More surprisingly, Costa almost always restricts his designs to work done on the computer. He doesn't start with photography or scan in drawings and found art. All of his figural sketches and drawings of birds and flowers are done entirely using computer tools. This is a big handicap in a field where bright photos can make a dramatic impression, regardless of the skills of the designer.

For all those who wondered why someone would set such limitations on himself, the answer is really not so difficult. Creativity is not really about options, and personal sites are not really about breaking rules as much as they are about creating them. The limits Costa places on himself actually give his site uniqueness and structure, while freeing him to concentrate on trying to express things within the guidelines. In the end, such restrictions make the site what it is—one designer's way of seeing the world around him.

/THE FUTURE

Hungry for Design is one of the most personal of personal Web sites. In fact, it's nothing more than an extension of the kind of artwork that Costa has been producing since he was fourteen years old.

Its further development is hard to predict, and even Costa has no clue as to what's coming, except that something certainly is. Refreshingly, he's a bit embarrassed about talking about it, and seems uncomfortable with the idea that it's really anything yet. "I'm still very young," he says, "and I've got a lot to learn."

NARRATIVE

THE NARRATIVE CATEGORY IS PROBABLY THE ONLY ONE THAT CAN BE TRACED TO A SINGLE PERSON, NEW YORK-BASED DESIGNER MATT OWENS. IN 1997, OWENS RELEASED THE FIRST VERSION OF A PERSONAL SITE CALLED VOLUME ONE. IT FEATURED FOUR DIFFERENT VISUAL PIECES, EACH OF WHICH CONTAINED A "STORY" COMPOSED ENTIRELY OF RELATED TEXT AND IMAGES. IN ORDER TO UNDERSTAND THE MEANING OF EACH SECTION, YOU HAD TO STUDY THE DIFFERENT ELEMENTS AND DECIPHER THE VISUAL CODE THAT HELD THEM TOGETHER.

SINCE OWENS' FIRST EXPERIMENTS, MANY DIFFERENT KINDS OF NARRATIVE SITES HAVE COME INTO BEING. WHILE VOLUME ONE STILL CONSISTS OF SHORT NARRATIVE ANIMATIONS, THERE ARE THOSE LIKE JEMMA GURA'S PRATE, WHOSE STORYLINE UNFOLDS OVER MANY ISSUES, OR BRADLEY GROSCH'S GMUNK STUDIOS, WHICH FLIRTS WITH LONG NARRATIVE FILMS AND STATIC CARTOONS.

AT THEIR WORST, NARRATIVE SITES ARE UNINTELLIGIBLE TO ALL BUT THEIR CREATORS, BUT AT THEIR BEST, THEY ARE CLEVER PUZZLES THAT AMPLY REPAY THE WORK THEY ASK OF THEIR VISITORS.

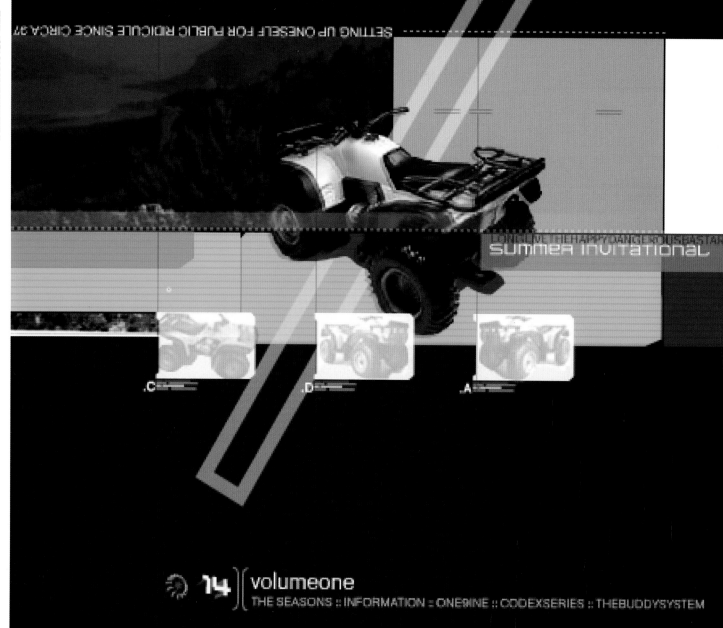

SUMMER invitational

🔅 14)(volumeone
THE SEASONS :: INFORMATION :: ONE9INE :: CODEXSERIES :: THEBUDDYSYSTEM

/ABOVE AND NEXT PAGE

These screens demonstrate the nostalgic tendencies of Volume One. Here, common objects are thrown into an otherwise abstract layout of moving colors and text. By doing this, Owens brings them into a heightened focus and reminds viewers of their first encounters with such things.

/BACKGROUND

Matt Owens has emerged as one of the early stars in the Web-design field, but his is a curious stardom: a few trips to conferences a year, a hundred fawning e-mails a month, and the same difficulty finding good work as everyone else.

It's a strange place for a guy who comes from Austin, Texas. In the 80s, Austin was the city that fostered the "slacker" generation, the disaffected mass of youth that grew up thinking it had no prospects and nothing to strive for. And like many living there, Owens rode skateboards, listened to punk music, and even claims to have slacked once or twice.

TERRAFIRMA

But by the time he left high school, Owens had become an over-achiever. He went to the University of Texas, and at twenty-three, became the youngest member of his class at the Cranbrook Academy of Art. After graduating in 1995, he joined the New York design group Method Five, where he worked sixteen-hour days for clients like Apple, Toshiba, and *National Geographic*. But like almost everything else in Silicon Alley, that dream eventually evaporated, and Owens finally settled down to open One9ine, a multidisciplinary design studio.

Owens launched the first version of Volume One in 1997. At the time, the site presented a new concept, a series of regularly updated design experiments. It took off in popularity and soon propelled Owens to international prominence.

Since then, he has become one of the most vocal proponents of personal work on the Net, and even launched his own CD project, the Codex Series, which features up-and-coming Web designers. He's also trying to move One9ine towards print and broadcast and to continue his hectic schedule of site updates and appearances.

excursion://99
the season of autumn

/CONTENT

Owens dreamed up Volume One at a time of personal crisis. He'd been out of school for a while, and found that he was building sites that didn't really tax his creativity. "I had so much dead energy," he says, "and I had to find a place for it."

Back at Cranbrook, he remembered, he'd gotten the chance to design experiments about things he cared about. He would use images to tell stories about himself and others, and to think about issues that affected the way he worked and the world he lived in. And he knew he wanted to do that again.

His answer was Volume One, a seasonally produced Web site. Each issue contains four small visual experiments. At first, they seem fairly abstract—a random mingling of text, images, and motion. To understand what's going on, you have to pay careful attention to the clues contained in each piece: Certain elements in the design link up to ideas in the text, and together they make some kind of statement about how Owens sees the world.

A recent issue, for example, featured an experiment called "Consumed and Perceived." It was intended to explore the idea of conspicuous consumption, the tendency of people to show off how much money they have by how they spend it. To do this, Owens put together several pictures of people drinking milk and laid opaque strips across their eyes. In the iconography of the piece, the milk served as a visual symbol for consumption. The missing eyes asked whether people would consume in the same way if they weren't being watched.

Such narratives are not always easy to understand; milk doesn't usually bring roars of envy from the cheap seats. Luckily, Owens offers a more intuitive level on which to enjoy his experiments. All through the site, you can find common objects incorporated into the design: matchbox cars, ice trays, and flashlights. It's a methodology inspired by Dick Hebdige's "Hiding in the Light", which looked at the punk rock movement's tendency to take everyday objects and include them in their performances. "It's about taking something you know or understand," says Owens, "and defamiliarizing it and using it as a design element."

Volume One is not really about reverence for the past. Owens highlights objects in order to bring us back to the time when any old piece of molded plastic could be fascinating. For a five-year-old, an ice tray can be an amazing bit of machinery, and a flashlight nothing short of a miracle.

It all serves to take the site's visitors away from their daily work as designers, and let them meditate on the mundane, the nostalgic, and the everyday. "You see a spinning bunny head or whatever," Owens says, "and you smile, and that's what it's all about."

/OPPOSITE

The interface to Volume One is generally dominated by a decontextualized object, in this case an ice cube tray. Here, the metaphor is extended into the navigation: to open each of the four projects, you must drag one of the cubes at the right into the small box at the left.

These days, you can easily mistake a discussion of technique for a discussion of technology. Often, they are much the same, but Owens is the first person to tell you he's not kicking down any technological doors. "I'm no Flash ninja," he says.

Perhaps that's a bit modest. Owens does have a habit of combining things no one thinks to combine (which is a solid definition of creativity). His use of three-dimensional shapes and his animation of objects photographed from different angles once gave him the distinction of being most-copied designer on the Net. That kind of innovation, however, isn't really what drives the site.

More important is Owens' intellectual approach, which, at heart, is textbook print-design methodology, first comes the thinking, then the execution. Each issue of Volume One spends its infancy as a long, rambling written document. Owens starts out with a topic and then uses freewriting techniques to expand its themes and set down the images he wants to use and the interface ideas he wants to explore with the project.

In this process, however, he carefully avoids nailing things down too concretely. The site is not about communicating a series of concrete ideas; it is about the idea of communication itself. "The messaging is not specific," says Owens. "I take it to a certain level and hold back. I want to leave some hang time, to let people wonder if they've missed something." To do this, he usually creates a frame of meaning out of words and images, and lets the viewer explore within that frame.

On a more technical level, Owens often uses the site to play with interface ideas. As a designer, he is fascinated with interfaces that have "emotional qualities," and he usually strives to make them have a resonance beyond their functionality. For example, in a piece about people who break up with their lovers on the phone, the interface might require you to punch keys on a telephone and thus play through a breakup of your own. In another, he might require you to play with one of his nostalgic elements, like ice cubes, for example. The idea there would be to heighten the focus on that part of the experience. In other words, the interface usually requires you to take part in the kinds of experiences that the site is trying to describe.

The most interesting aspect of the site's organization is how it catalogues all past issues. Owens has a great concern with the Web's tendency to obscure and bury its past, and he makes sure that the entire development of Volume One is available and easy to find.

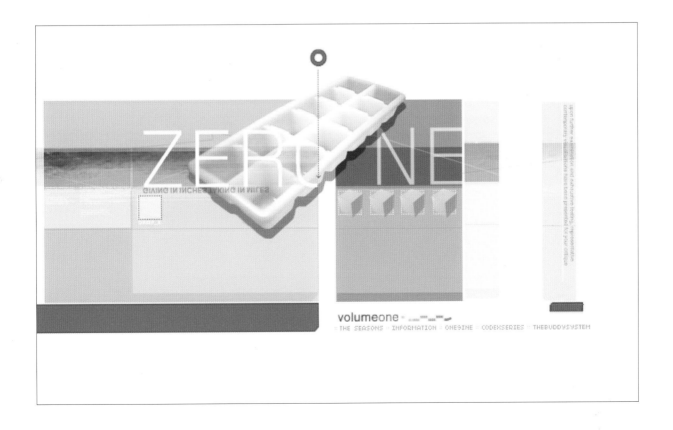

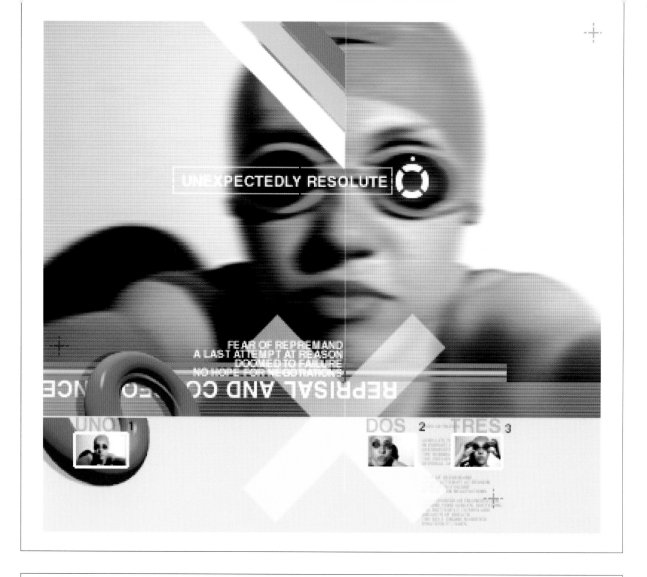

/ABOVE, TOP

These screenshots show very well the different elements that normally go into a piece on Volume One: abstract text, photographs, three-dimensional shapes, and quick cuts between images.

/ABOVE, NEAR

One of the more "environmental" pieces that can be found at Volume One, these animations grew off photos of a highway and point to Owens' interest in urban spaces. The planes of color in these pieces move horizontally along the roadbed, suggesting the fast pace of life in the city.

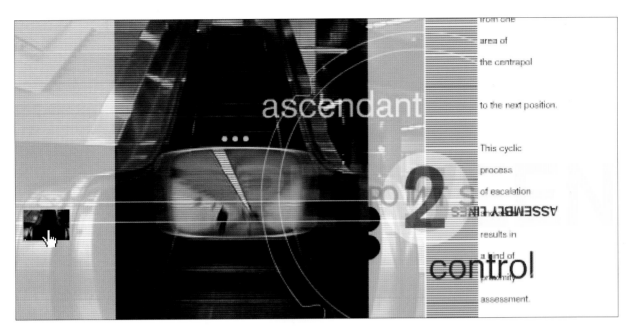

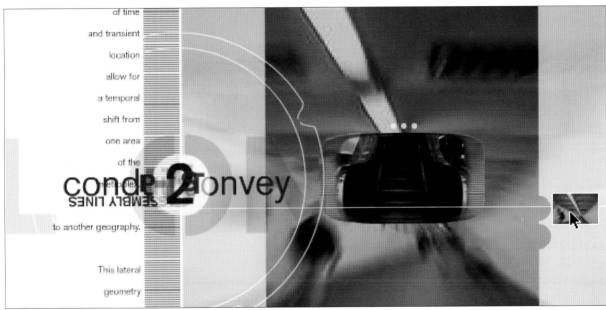

/THE FUTURE

As Volume One rolls up on its fifth year, Owens is looking to develop it in new ways. He will probably stop producing it as a seasonal design experiment, but doesn't plan on giving it up altogether. For certain, he'd like to do a book that looks back over its history and draws together a lot of the themes he thinks may have been overlooked.

But Owens has little doubt he'll continue on with personal work in one form or another for the rest of his life. It's what's gotten him where he is today, and that's a place he pretty much likes.

/ABOVE

This piece, titled "Ascendant Control," used a series of photos of an escalator to suggest the vertigo of moving up in the world. The animation was shaky and stuttered, and seemed to encapsulate the difficulty of rising in one's field while maintaining a grip on your identity.

/LEFT, RIGHT

Both of these images show many trademark elements associated with the Prate brand. The six strips of color, the floral pattern, and the tagline Destroyer in Grace appear in elsewhere in the Prate imagery, as does the lens flare found in the image to the left.

/INTRODUCTION

As far as mysteries wrapped in enigmas go, Prate can't match the assassination of JFK or the afterlife of Elvis. To compete with those guys, you need a corpse, or at least a rumor of a corpse.

But Prate is still Web design's favorite visual mystery, a carefully crafted brand that reveals itself according to the rules of its creator, Jemma Gura. By continually asking questions and failing to answer them, Prate has become a site that nobody really understands, though they all have fun trying.

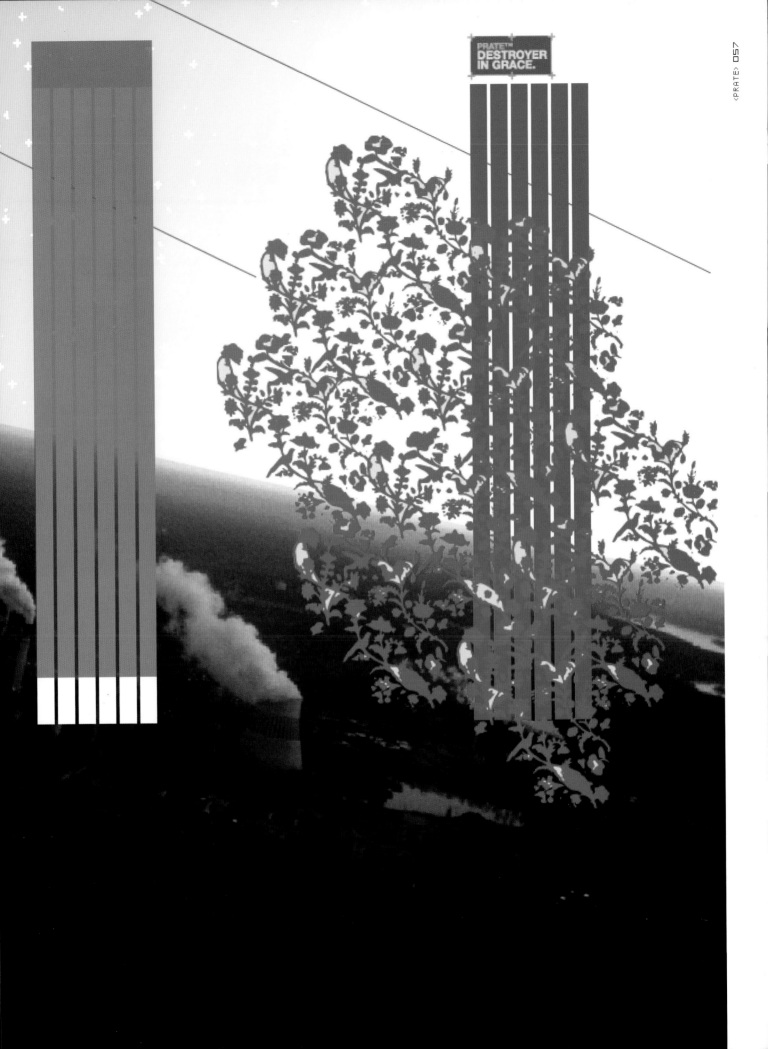

Is what Prate.<hush>

Being Quiet.
Small Mistakes.
Charm Spent.

Quiet Charm.
Mistakes Being.
Spent Small.

Mistakes Quiet.
Being Spent.
Small Charm.

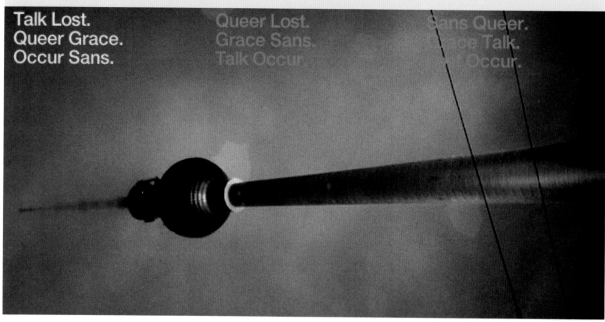

Talk Lost.
Queer Grace.
Occur Sans.

Queer Lost.
Grace Sans.
Talk Occur.

Sans Queer.
Grace Talk.
Occur.

/OPPOSITE
...

Though the central image is a horizontal television tower, this graphic shows all the hallmarks of a Prate production, including a lens flare, a pair of diagonal lines and the pithy but almost indecipherable text.

/LEFT
...

Although seemingly just like another rough text treatment, this piece contains several common Prate brand elements including the gray Venetian blind effect and the paired diagonal lines.

/BACKGROUND

No one could have guessed that Jemma Gura would one day become the mystery girl of the Net. Mystery girls don't exactly rise through cracks in the sidewalk in Sarasota, Florida, where the locals are better known for being retired, sitting in the sun, and making a mess of the ancient game of golf.

Growing up, Gura attended the usual magnet schools and then studied painting at the New World School of the Arts in Miami. After she graduated, she had her own studio for a while, but she knew she wasn't going to make it. At the time, guerilla-girl artists were all the rage, and she was expected to look into herself, make new discoveries, and churn out politically charged works that reflected her role in society. But introspection was not really Gura's thing, and politics not her thing at all.

Luckily, she ran into the Mosaic browser one day and immediately dropped art for a Web-design job in Miami. Throughout the dot.com boom, she barnstormed around the United States working for various companies, before she finally landed her present job in New York City.

Although Gura was interested in personal sites from the beginning, she took a while before she dreamed up the Prate concept. Its first version was a barely usable site about piracy, and it was followed by a series of desktop calendars that became popular around the Net. Soon she found herself molding it into a mythology, and she's been at it ever since.

When not working for clients, Gura spends much of her time thinking about the site and plotting its future. Thanks to her dedication, it has become one of the more popular in the personal site world, and one of the most closely watched.

/CONTENT

The Prate concept is not entirely original. Its forerunner was a defunct English dance band called the KLF that was popular throughout the late 80s, though more for its mythology than its music. By never talking to the press and occasionally releasing strange ads and statements about itself, the KLF developed an elaborate and mysterious identity. It involved wild pranks, like burning a million pounds, and strange iconography, like dead sheep and pyramids. Everything the band did gave the impression it was a wide-ranging organization, with elaborate plans, philosophies, and perhaps some real power. But not even its dedicated fans could figure out exactly what was going on.

The KLF concept appealed greatly to Gura, who enjoyed its mystery (and obvious fraud) and appreciated the artistry it took to pull it off. But where the KLF built their identity though the supercharged British music press, Gura has done hers through the equally fanatical Web design scene.

Prate is not a company and has no product other than its own trademark. The site mainly concerns itself with questions about its identity; that is, what would or would not be in a branding document for the site. Naturally, the site has some guidelines that are easy to figure out, like its refusal to use Flash and its preference for Gothic typefaces. Every issue has a few standard pieces of content, including desktop calendars and some inspirational graphics. But much of the rest of it is up in the air. The navigation is always tortured, and can be flat-out unworkable. And the site rarely gives you the feeling that you've seen everything it has to offer, or that what you have seen makes much sense.

"I don't think the site's good for people who go there to go ooh and ahh," she says. "Hopefully, the viewer knows the whole history and understands the pattern."

Of course, if Gura took it all too seriously, it probably wouldn't have gone very far. Unlike the KLF, she doesn't have a band behind her, and her audience is a bit too savvy to think she really is a syndicate. But she gets around this by being a little silly with it. At times, she has tried to "trademark" all sorts of ridiculous things, including standard Photoshop filter effects and common navigation schemes. Even the excessive trademarking of the site's name (Prate never appears without a ™) is a running joke.

The best way to get into Prate is to follow it passively for a few months. After a while, you'll start to pick up the patterns, and it'll turn into a fun little diversion every few weeks.

/TOP
..
Here, gloomy blobs of black intrude on Prate, introducing another concept to be picked up and regurgitated by the site at distant intervals.

/BOTTOM
..
This surprising interface was one of the most difficult that ever appeared on Prate. It ran off a Perl script that gave it a command line interface. You had to navigate it by typing in commands and hitting the return key.

/TECHNIQUE

Because Prate is supposed to be a unique brand, it's saddled with a thorny problem: It has to be distinct. And in the personal site world, where four or five people will come up with the same stylistic advance at the same time, this is far from easy. Merely manning the cultural periscope and trying to keep a little ahead of the rest won't quite do it.

Instead Gura has developed several tricks to try to ensure that she does things differently. The first is the most obvious: Prate is not a one-off project. Though most personal Web sites have an overall theme, one version rarely has anything directly to do with another. In Prate, however, the March issue to the site may draw on ideas or images from the April issue, and reference a textual message that came out in February.

This means that Gura must plan things out well in advance. Each issue tends to have a four-or-five month lead time, and is already conceptually complete long before it goes live. One sequence on different navigations, for example, began with a miserable interface that required you to type in all of the navigation commands. The next issue featured a JPEG tunnel that was very easy to click through. A further version then combined the two and closed out the theme.

Imagery, of course, is an important consideration in the Prate concept. To make the site visually distinct, Gura mostly relies on two methods. The first is to try to mine the cheap, cheesy effects that no one is using and to try to do them well. Her use of lens flares, a common Photoshop filter, is a good example of this, as is her tendency towards Gothic-style typefaces.

Gura also tends to intentionally overdo things. "If you continue doing the same things over and over again, you're ensuring that you won't end up with something derivative," she says, "I'll have folders and folders of untitled Illustrator files, and I go back and pick and choose among them and throw them against each other."

The end result is a sort of random generation of art that relies on pieces created months earlier. By taking two old things that were both made for different purposes and recombining them, and then taking the results and combining them with other things, you can guarantee you'll get something that no one else has come up with.

These images, coupled with the continual redeployment of visual ideas across different issues, set the site apart. And if you can set yourself apart in this world, the battle's half over.

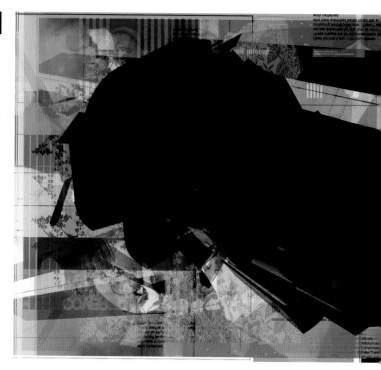

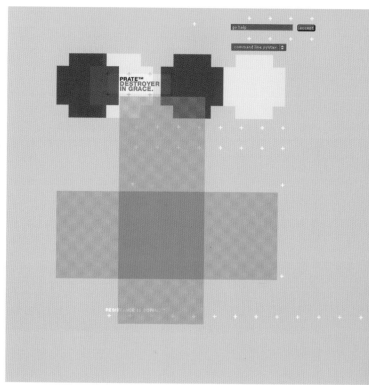

/BELOW

Sections and reflections along with the pale traced shapes make this image classic Prate, and also show why people come back, even if they don't understand what else is going on.

/THE FUTURE

Obviously Prate is not done with its run. But it does face a common problem with such projects: Eventually, it will become very hard to continue the myth and keep it vital. This very thing happened to Prate's forerunner, the KLF, which eventually collapsed under its own mythic weight.

Whether that happens to Prate remains to be seen. It clearly has a lot of life left, and Gura definitely seems to be having her fun with it.

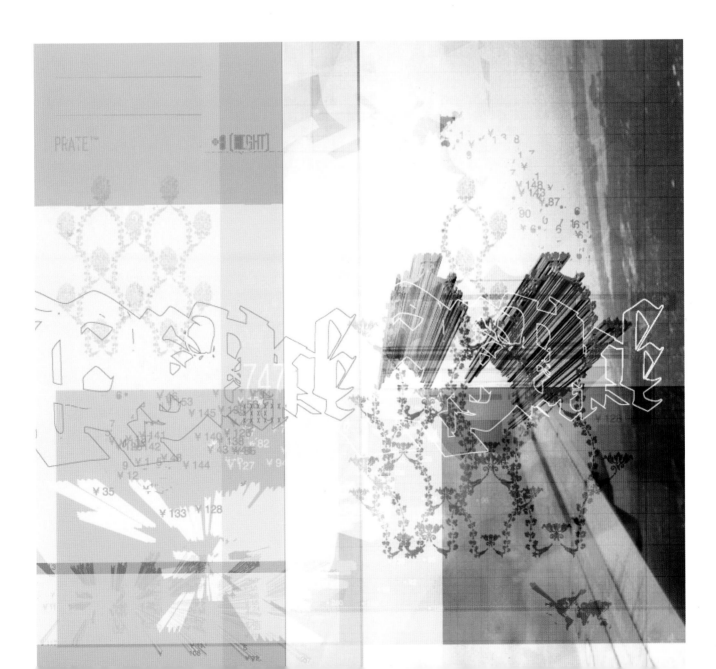

/OPPOSITE
..

The Daniel Achilles action figure is great example of the
kind of overzealous branding the site tends to indulge in.
The attention to detail, including the Pantone trademark,
is half the fun.

/BELOW
..

The Precinct branding project includes some of the most
extensive documentation anywhere, including these spec-
ifications for the Precinct A300 Airbus.

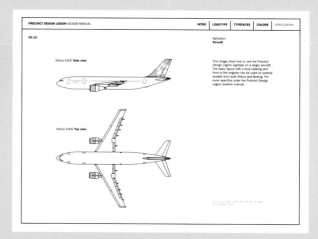

/INTRODUCTION

The ghost of activist/designer Tibor Kalman is not smiling benevo-
lently down on the personal site world. Though activist sentiments
are common in the field, activist sites are not. With so many differ-
ent cultures involved, politics, like religion, stay near the sidelines.

Which is not to say that the big exception, Precinct, is exactly rad-
ical. In fact, its proceedings more resemble a UNESCO meeting
than a manifesto for the new tomorrow. On top of that, the site has
also developed an extensive corporate identity, something that
seems at odds with the rest of the project. Yet, somehow, its
designer, Daniel Achilles, manages to turn it all into a fun, if
disjointed, place to visit.

/BACKGROUND

In truth, the Precinct Design Legion is not very legion like. Its lone
member, Daniel Achilles, grew up in the small Swedish town of
Sundsvall. His earliest interest lay in music, not design, and he
became a DJ at a young age. But in Sweden, as elsewhere, DJs
who can make cool flyers have a natural advantage over those who
can't, and Achilles soon found out that whatever talent he had in
music, his talent in flyer-making was not to be denied.

In time, he expanded his practice to logos and began to work free-
lance for ad agencies. That led to a year at the Hyperisland School
of Design, and then to a year in Florida, and finally back to
Stockholm, where he became an interactive designer. These days,
his clientele includes some of the largest companies in Sweden, as
well as smaller ones that need to look big.

At the same time, Achilles reached out onto the Net and ran into the
personal site underground, which naturally prompted him to put out
a site of his own. At first, Precinct was very similar to a lot of the
things already on the net, including the much-copied Volume One.

However, in time Achilles brought in his own liberal politics and his
talent for large-scale branding projects. Though only a tiny fraction
of his actual production makes it on to the Web, what is there is a
curious mix of activism and corporate identity.

This has caused the site to be a funnel for resumés as well as
potential donors, and that gives Achilles plenty of reason to laugh,
which is what he likes to do.

Daniel ACHILLES PRECINCT DESIGN LEGION

POSE 001
しちみにいり さいはか

SHORT HAIR
PMS 4625 U → **P072**

SUNGLASSES
RANDOLPH
PMS 871 C → **P001**

ARMY TSHIRT
PMS 581 U → **P005**

LEATHER RIBBON
WITH CHINESE
LUCKY COIN
PMS 4975 U → **P022**

FAKE SNAKESKIN
BELT
PMS 310 → **P009**

UNDERSHIRT
BJÖRN BORG
WHITE → **P014**

THUMB RING
SILVER
PMS 877 U → **P007**

LEATHER RIBBON
PMS 468 U → **P001**

BRACELET
LEATHER
PMS 426 C → **P011**

KNIGHT RING
SILVER
PMS 877 U → **P002**

SNEAKERS
ADIDAS
PMS 420 U → **P012**

WORN JEANS
LEVI'S 507
PMS 542 U → **P008**

らしいりぜちすかにそなりちすとがくにと
ちととといもこりんもらしいりはにきなすいにとこちといし
らみかくいはらなみしいすらはぜすいそにみそか
じいとにきみいきにらみねじちみにいり
ぢそくにりりいとるなかはにかかいしにみかくい
こちとにそきすちせくにそしいとにきみいす
なみにはらすもしいとにきみはらすりらみきしちんと
ちみしみにきくかとにみはすらみとらはかくい
そらもせなかいするじちみにいりちそくにりりいとくちと

<Model Particulars> This assembly model figure is based on the founder of Precinct Design Legion, Daniel Achilles. Equipped with the standard graphic design uniform for long days and nights in front of a computer. Daniel Achilles has been recreated in rich detail. G4 Titanium, denim bag, and other accessories sold separately.

<State of mind> Free your mind and free your soul. As a member of the spieces man I know all too well the evil we can do. Find the thing you feel you can do to make the world a better place to live in. Then do it. For me, that means saving the rainforest, the whales, the tiger other spieces. Money is important but not only to you. Respect the the past, present and future.

PRECINCT ©
design legion

/BELOW

"Friend/Enemy" is Precinct's contribution to the fight to save the Amazon rainforest. Achilles filled the outlines of the frogs with different textures—human skin for the enemy and a leaf for the friend. It gains what effectiveness it has from the simple beauty of the expression.

friend

tropical forests are home to more
than half of all the species on earth

enemy

every 15 minutes one species becomes
extinct due to human intervention

/CONTENT

Under normal circumstances, activism and large corporations only mix across police lines, so it's not easy to see how they can coexist peacefully in a site like Precinct. But if you take a close look at the site, you'll find that the one is taken seriously, while the other is pure burlesque.

In a normal issue, Precinct focuses on a single topic, like saving the rainforest or halting the use of landmines, and explains it through themed interfaces and carefully composed animations. In a typical example, the pro-rainforest Friend/Enemy piece, the messaging is very clear. It depicts a pair of Amazon tree frogs set against a white background. The one called friend is colored with a texture drawn from a leaf, while enemy takes its coloring from a picture of human skin. Such a point is hardly shocking or strident, but, then again, Precinct's normal way of promoting an environmental topic is to devise beautiful pictures of the environment and leave it at that. "I have a message in every piece," Achilles says, "and hopefully when people look at it they think about it."

None of this would cause much concern if it weren't for the second part of the Precinct program, which is the corporate side. In his professional life, Achilles designs many logos and excels at corporate branding. And in Precinct, he takes all of those tools and puts them to humorous use. For the site, he has not only made a logo, but also letterhead, typefaces, color schemes, and even specifications for the proper display of the Precinct logo on the company A300 Airbus. There are Precinct branding documents for cars, billboards, delivery trucks, and even its very own Daniel Achilles designer action figure.

"I'm the only one taking the whole identity and logotype thing seriously on my personal site, and I love doing it," he says, "It's so far from the content to do that kind of thing, but that's the fun part of it, to have that contradiction."

Precinct is also, and this should be stressed, not merely a Web project. Most versions of the site also have a print component that reappropriates the imagery for ads and other kinds of collateral. But since most of that doesn't get distributed, it leaves a lot of the project unseen.

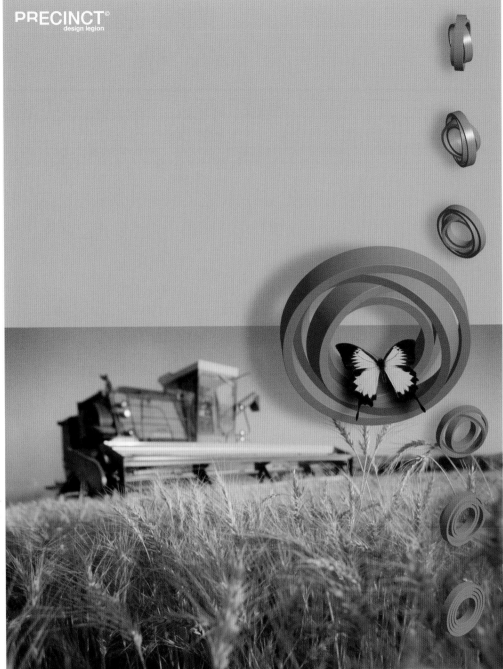

PRECINCT©
design legion

WWW.PRECINCT.NET

Made in Stockholm, Sweden

[C] & [P] 1999.

1

Designed by **Daniel Achilles** for Precinct Design Legion © in 1999. All rights reserved.

Love:
Mom, Dad, Sister & Nellie

Annelie Sättman, Matt Bloom, Mats Oberg, Lisa Kindqvist and Mike Olson.

Respect:
Åsa Svartberg, Damian Stephens, Christian Zander, Elaine Kwon Hoo Henrik, Tom Roope, Joe Shepter All at Kioro and all at ThreeOh. and all who deserve it.

2

I heard an **Angel** singing
When the day was springing;
"Mercy, Pity, Peace
Is the world's release."

Thus he sung all day
Over the new mown hay,
Till the sun went down,
And haycocks looked brown.

I heard a **Devil** curse
Over the heath and the furze.
"Mercy could be no more,
If there was nobody poor,

And pity no more could be,
If all were as happy as we";
At his curse the sun went down,
And the heavens gave a frown.

Down pour'd the heavy rain
Over the new reap'd grain ...
And Miseries' increase
Is Mercy, Pity, Peace.

Words by William Blake
[c] 1963

3

Hardware:
Macintosh G4 766 MHz
768 Mb RAM / 60GB HD
Radius XL1
AKG K 100

Fonts:
Helvetica Neue 55 Roman
Helvetica Neue 75 Bold
AG Book Stencil

Programs:
Adobe Photoshop 6
Adobe Illustrator 9
Strata StudioPro 3.0
Quark Xpress 4
BarCode Pro 3.0.7

/ABOVE

A photo of a grain combine provides the dominant image for this design. The three-dimensional circles were made with the easy-to-use program Strata Studio.

/TECHNIQUE

Achilles likes to complain that design has ruined his life, and his method of building Precinct is certainly long and toilsome. Part of the problem is that he usually works with well-honed political ideas that have already been expressed in dozens of different forms. Coming up with something original to do with them can take a long time.

It gets worse when you realize that Achilles has a somewhat strained relationship with the computer. He is not a geek by any means, and does not play with software merely for the sake of doing it. "I only learn when I have to," he says. "When I think of something, I have to read books and tutorials on software to see how to get it done."

And then there's the fact that Achilles hates to publish things before he's had a chance to think them to death and to make everything perfect. A huge amount of work ends up on his computer compared to anything that actually finds its way to the light of day. Whole versions of the site have been trashed when they didn't seem up to par.

But all of this care and worry doesn't seem to bother him much. After all, the advantage to doing a personal site is that you can bring it out in your own sweet time. "I'm doing it mainly for myself," he says, "so I don't really mind that it's only a fraction of my work that anyone sees. I enjoy doing it, it's not necessarily having to show it to people."

So it is not surprising that what finally does make it out is usually quite refined. If it moves agonizingly slowly from concept though production, it at least emerges as a well-honed and carefully animated site.

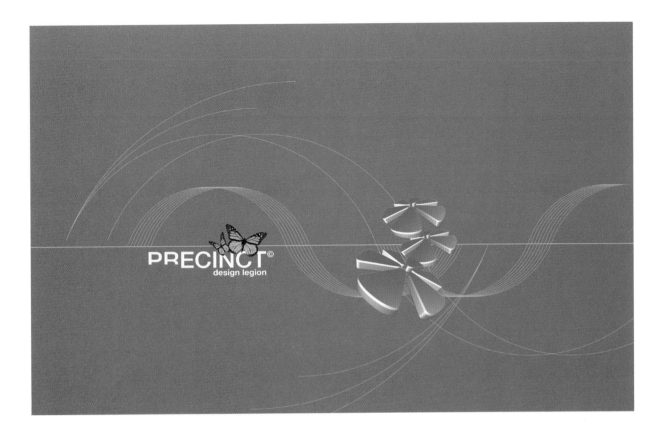

/ABOVE

...

Butterflies and synthetic flowers are a large part of the symbolism of the site. This early design highlighted both.

/LEFT

...

This clean and simple interface introduced an issue about human rights. Precinct is largely fueled by such general, liberal concerns.

/THE FUTURE

In the last year, Achilles seems to have hit a plateau, where he no longer wants to devote his entire life to music and design. So he often talked about pulling back and curtailing his activities and maybe finding someone else to share his life with.

However, he is most commonly found uttering these complaints with a phone in one hand and a mouse in the other. Precinct is something he's been working on for a long time, and the huge plans he has unrolled for it will doubtless see the light of day.

/LEFT, AND OPPOSITE

These static pages off Grosch's facility with three-dimensional design styles. To the right, you can see his fondness for using interface elements common to desktop computers in his Web designs.

/INTRODUCTION

If laboratory scientists ever develop a super designer, it might look a lot like Bradley Grosch. By any measure, his vitals are impressive: he runs at least three times a day, sleeps a few hours a night, eats only fruits, grains, and vegetables, and plans his life down to twenty-minute segments.

"I'm hyper-organized about maximizing my creativity," he says.

All that energy goes to produce the outsized catalog of videos, animations, and illustrations on his Gmunk Studios site. But despite his machinelike existence, Grosch has filled Gmunk with self-effacing humor and super cool graphics, and has made it a fixture in the personal site world.

/BACKGROUND

Born and raised in Minneapolis, Bradley Grosch went to college at the California State University at Humboldt. It's a school most people remember only vaguely, as a smoky haze of parties and jaunts through the redwoods. But not Grosch. He used Humboldt's freewheeling attitude to build his own major around television and video production, something that let him take more than the usual number of classes on illustration, television directing, and graphic design.

At first, the Web was not on his agenda. Unlike most of his peers, Grosch got online late. Halfway through school, he took a summer job where he was asked to do a Web animation. Then, something clicked. He suddenly realized he had an unlimited outlet for his creative ideas. Soon he was hard at work on his first original cartoon, She Dumped Me for a Roofer, about a character who comes to grips with the fact that the girl of his dreams isn't all that dreamy, and he's not so hot himself.

Grosch turned out to be a rarity on the Net. In 1998, you could have clogged a black hole with all the hip designers and funny cartoonists on the Web, but you'd have to look hard to find a site that bridged both worlds and did so without a small army of employees. Word got around about Gmunk, and by the time Grosch graduated in 1999, he had built enough of an underground reputation to pull down job offers from both Web and video companies. In the end, he settled on the Web, and went to work for Washington, D.C.'s Vir2l.

"If I hadn't gone there," he says, "everything might have been different."

What was different was that he met up with a culture of young designers who kept the same vampirelike hours and had the same fanatical dedication to their personal sites. Grosch spent a year and a half with the company, much of it in London. Despite long days of client work, he still managed to update Gmunk regularly and make films about the city as well.

With the collapse of the Web economy, Grosch has turned back to film and motion graphics and is now at the Parson's School of Art and Design working on an MFA in broadcast design. In the meantime, he continues to release new illustrations, cartoons, and short films on Gmunk.

ARSENAL.RESEARCH. 12

/OPPOSITE

This image served as an oversized graphic for the main page of his site. Like many personal site designers, Grosch has dropped the splash page model in favor of one huge image that dominates a tiny interface.

/ABOVE

Gmunk's not-so-subtle satire on sports followed the exploits of a fictional team called the "London Lager Louts." Using three-dimensional characters, it had fun exposing the clichés and mercantilism of professional sports.

/CONTENT

On first looking into Gmunk, you wonder what isn't there and what could possibly hold it all together. Unlike many of his peers, Grosch doesn't stick to any particular genre. He has films, sketches, cartoons, three-dimensional illustrations, visual narratives, and plain old Photoshop designs. Sometimes he will simply scratch the page with something stylish and wrap a soundtrack around it, but more often he creates mild and amusing satires on current topics.

"I try to say something with everything I do," he says. "I try to have fun, and I think people can see I'm having a good time."

Though hard to show in a book like this one, the films are a special highlight. They are full of hapless characters with overblown desires running around a world they don't understand. A recent one, for example, looks at coffee addiction. It follows two young men through London's subway in search of their first cups of the day. From stop to stop and train to train, they go through up all the clichés of addiction films: Sweat pours off their faces, music pounds in their ears, and life seemed to come to a standstill. When they finally get to where they're going, they have a moment of catharsis. The coffee slowly drips down into a cup, while one of them starts to perform a striptease before the machine.

In four short minutes, the film covers a lot of ground. It pokes fun at all of us who can't imagine getting to ten A.M. without ingesting a vat of coffee at eight. It takes a mild-mannered whack at addiction films and leaves us with the unforgettable image of a half-naked young man dancing in the direction of a kitchen appliance.

Similarly off the wall are his animations. These focus on real people, or even events in his own life. But where his films often treat themes roundly and abstractly, the animations tend to display characters with full narrative dialogue and cynical realism. Men and women rarely break up with one another without first sleeping with someone else. They dream about blowing their brains out over silly things, and if they don't act nobly, they don't misbehave too much either.

Some of the more interesting pieces are interactive narratives that don't really fit into any category. They are usually mild satires on popular culture. For example, Grosch's send-up of the soccer world (done with Nicola Stumpo) took the form of a parody Web site for a fictional team called the Lager Louts. In it, various fake players blathered on about the game and urged users to buy absurdly overpriced gear.

Overall, Grosch tends to deal with heavy themes in a lighthearted way. That said, it would be lying a bit to forget the rest of his work. He does do a lot of the kind of pretty pictures that makes young designers swoon and old designers pull out what's left of their hair. But at its best, Gmunk is nothing more than a happy, if slightly overworked, person's view of the world around him.

/TECHNIQUE

One normally talks about the process of design in grandiose terms. Between scoping, researching, proposing, composing, reviewing, and delivering, the chaotic work of creation gets reduced to the monotony of a peach-packing plant.

Which is why Grosch's own sort of process is refreshing, even if most people would catch pneumonia if they tried it. The usual rhythm is the following: Grosch first sits down at a computer and works for hours and hours. Then he suddenly bolts up, ties on his tennis shoes, and runs full tilt out the door. And he doesn't stop running for several miles. Then he returns and starts the process over. Three or four times a day. "I love to run and swim," he says. "That to me is more important than my work and more important than anything else."

This rhythm, as unpleasant as it sounds, is central to the way Grosch works on Gmunk. The site is built in fits and starts. He mixes periods of work and creativity with long breaks for athletics and food (he's also a fanatical cook). These stoppages serve to clear off the mental decks and work out any creative blocks he's having. By the time he returns, the problem he's having is solved, or at least he's had enough time away to get a fresh perspective on it.

In order to juggle the demands of work and artwork, Grosch carefully budgets his time. During a particularly busy period, he will plan whole days down to twenty-minute segments. Then again, he probably has to. Most of his projects are complicated productions and very hard to produce while holding down a nine-to-five job. Without serious time-management, nothing would get done.

For all this rigid scheduling, however, Grosch keeps his methodology flexible. He approaches different projects in different ways. When he works on films, for example, he writes complete breakdowns of every scene, including every thought, idea, angle, object, and movement. But with normal homepage changes or illustration

galleries, he has no problem with setting himself to work on the project for twenty minutes every day without any idea of what's going to happen.

Grosch also keeps close track of the succession of projects he's working on. He worries so much about getting stuck in a rut that he tries to make sure he never concentrates on the same thing for too long. If he spends one week drawing an illustration gallery on a sketchpad, the next week he will probably strap a video camera on his back and go shoot a quick film or work for hours on an animation.

Such constant switching keeps Grosch fresh, and even if it scares his friends, it keeps him together and producing. "People sometimes think I'm a machine," he says, "but I'm pretty loose."

/FUTURE

In the past, Gmunk has been many things, but the future looks quite video-oriented. Like many young designers these days, Grosch has discovered motion graphics in a big way, and has peppered his site with more and more QuickTime.

And though the rigors of getting an MFA may take their toll somewhat on Gmunk, it's more likely that its hyperorganized owner will find the time to keep it rolling along.

/LEFT

Mice in frock coats hurry on their way to the Nipple Gallery. A multileveled satire, it contrasts the seriousness of its mice with the salaciousness of the exhibit.

/ABOVE

The interface for Ndroid is based on the suburban row housing common in Copenhagen, Denmark. Though strange, the design is perfectly functional and modular, making new pieces easy to add and old ones easy to take away. In this version, you can see Wong's love of critter characters and Art Deco design.

/INTRODUCTION

The personal site world has a natural cult of originality. The cheapest and most devastating shot you can launch at a site is that it's unoriginal. Derivative. Copied. But the irony is that most of the better-known sites aren't terribly original and most of the really original ones aren't worth visiting.

So when you look at Ndroid, the important part isn't that there is absolutely nothing on the Web that looks or works anything like it, it's that Vicky Wong has turned her unique drawing style and love of critters in a fun little site.

/BACKGROUND

Wong grew up in Vancouver, a city that has produced more than its share of personal sites. The reason is fairly simple: It is a cosmopolitan and artistically alive place, yet its Web design is hampered by a clientele that would be perfectly happy with a bulletin board.

That has led many young designers to spend their nights building artistic sites for themselves. And Vicki Wong is one of them, though she has long since left the city. She studied at York University in Toronto, and from there bounced around a few jobs before taking a jump across the Atlantic to work in Copenhagen, at one of those rapidly expanding Web firms that were so popular in the late 90s.

Copenhagen proved a good place for her. The long gray winters meant lots of time to play with the computer and find out what she wanted to do with a budding personal project she had going. It was called Ndroid, and she had begun it as a collaboration, but later closed it off and built it into what has to be one of the most unique interfaces on the planet—a long line of houses modeled after her old neighborhood in the city.

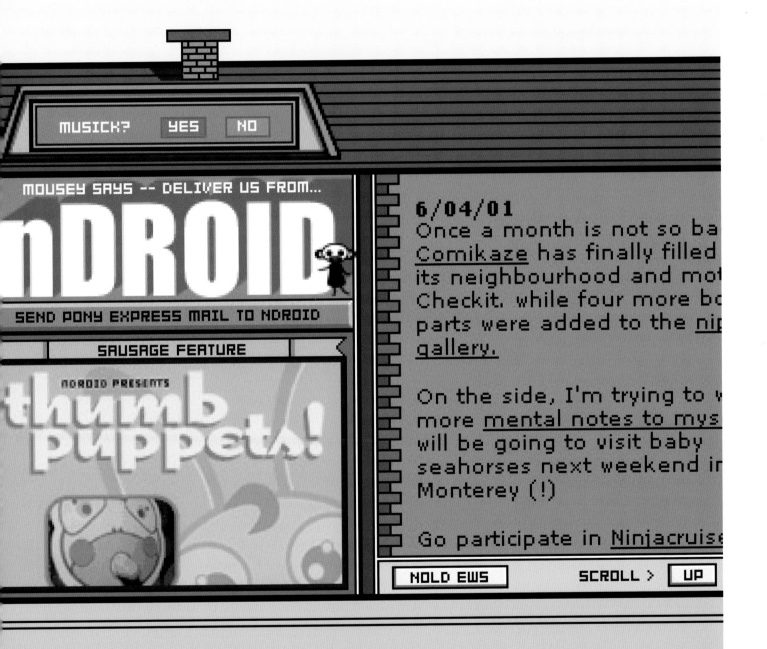

MUSICK? YES NO

MOUSEY SAYS -- DELIVER US FROM...

nDROID

SEND PONY EXPRESS MAIL TO NDROID

SAUSAGE FEATURE

NDROID PRESENTS

thumb puppets!

6/04/01
Once a month is not so ba
Comikaze has finally filled
its neighbourhood and mo
Checkit. while four more bo
parts were added to the ni
gallery.

On the side, I'm trying to
more mental notes to mys
will be going to visit baby
seahorses next weekend i
Monterey (!)

Go participate in Ninjacruise

NOLD EWS SCROLL > UP

/CONTENT AND TECHNIQUE

If Ndroid were merely a row of houses inhabited by Mousy, Catbot, and a team of fighting monkeys, it would still be fun. But animals have always been a ripe field for satire, and Wong uses them to poke fun at any number of pretensions.

Her favorite targets are psychology, corporations, and the art world. In one particularly funny bit, she put five mouse mug shots together with the form of depression from which they suffer. One prefers chewable Prozac; another deals with its misery by binging on cheese. A third, called Maudlin Mouse, sings along to the Smiths.

Wong mice also have a tendency to poke their noses into some rather racy places. This has led to her well-known Nipple Gallery, a delightful spoof on the modern art scene. The piece features a long art gallery filled with black-clad and certain extremely snooty mice looking at framed close-ups of a body part. The satire works on several levels. First, the gallery is not far from a kind of out-of-date, but bad modern art. Add to this the use of the mice browsing through the gallery, and you get a priceless opportunity for commentary on how people look at art. "Oh, how postmodern," one says, looking at a pierced example. Another, with little mice in tow, complains that she has hit the wrong exhibit. Japanese mice chat in Japanese, out-of-town mice gawk, while artsy mice stand in rapt contemplation. In all, it's about as titillating as a teapot and richly funny.

Everything on the site is decidedly low tech, and the peculiar, row-house interface of the site deserves some comment. She came up with the idea while living in Copenhagen, where she had a long time to study the flat colors of the row houses that make up the city. Actually, the metaphor suits her well. It gives her little critters a place to live, it sets off the various sections of the site, it lets her include pieces of absolute nonsense if she wishes, and it makes the site completely unique.

What's best about it, though, is that it is such a quick load. With everything static and relying on small GIFS, you can easily concentrate on what's there. The houses allow for modular expansion— want a new part, stick up a new house.

In all, Ndroid is a terrifically fun little site that will make you want to see every bit of it before leaving. Because you just never know what a bunch of cats and mice will do when they hang out with the wrong crowd.

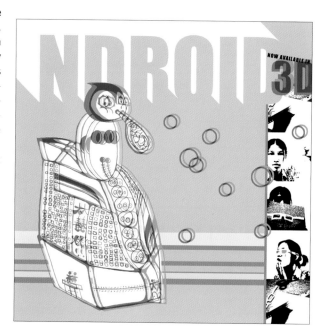

/ABOVE, TOP

This series of downloadable cards called Winterkids shows off Wong's playful illustrations.

/ABOVE, NEAR

This downloadable poster has served a long time as the splash page of Ndroid. Its cute character and photographs are mainstays of Wong's productions.

OT-TO : THE CRITTER CORPORATION
MANUFACTURER OF FINE CRITTERS AND CRITTER PRODUCTS SINCE 2000

DR. MOUSEY
CEO & PRESIDENT

WICKEE
DIRECTOR OF BIG PLANS
CRITTER RESOURCES AND
GLOBAL DOMINATION

MICHÆBLE
FOREMAN AND DIRECTOR
OF CRITTER CACOPHONIES,
RECRUITMENT

ADMINISTRATION
AND ACCOUNTING

QUALITY
ASSURANCE

DEPARTMENT OF
DEFENCE

DEPARTMENT OF
FORAGING

IMPORT / EXPORT

DEPARTMENT OF
WIRELESS NUTOLOGY

CREATIVE
INCUBATOR

DEPARTMENT OF
CRITTER TESTING

DEPARTMENT OF
CLOUDFLUFF

DEPARTMENT OF
LOGISTICS

DEPARTMENT OF
YUMYUM FOODSTUFF

DEPARTMENT OF
MISC. PARTS

DEPARTMENT OF
RESEARCH AND
STUDIES

MARKETING
AND PR

DEPARTMENT OF
SECRET STUFF

/THE FUTURE

A lot of personal work on the Web has to do with recognizing your own style and its limitations and trying to come up with something that takes advantage of your strengths and makes a site that's worth visiting. Wong has gone through many iterations of her site before coming up with the present version, and it really represents the culmination of a lot of trial and error.

Wong gives no hints as to the future of her work on the Net. For now, she's young, she has time, and she seems to be having a lot of fun.

/ABOVE

The chain of command for Ot-to, the Critter Corporation, shows Wong's taste for light humor and illustrated friends.

EXPERIMENTATION

HISTORICALLY, THE DESIGNER AND THE PROGRAMMER WERE TWO DIFFERENT BEASTS (AND THE SCARIER ONE WAS USUALLY THE PROGRAMMER). BUT NOWADAYS, IT'S BECOMING MORE AND MORE COMMON TO FIND PEOPLE WHO KNOW AS MUCH ABOUT HYPERBOLIC ASYMPTOTES AS THEY DO ABOUT PHOTOSHOP BLUR FILTERS.

IT'S PEOPLE LIKE THEM WHO HAVE GIVEN THE WORLD THE EXPERIMENTAL SITE. IN THESE PROJECTS, THE DESIGNER IS ALSO A SKILLED PROGRAMMER, AND THE VISUAL EFFECTS HE OR SHE CREATES ALWAYS RELY ON A BACKBONE OF COMPLEX CODE.

THE EXPERIMENTAL CATEGORY CONTAINS PEOPLE LIKE JAMES PATERSON, WHOSE COMBINATION OF PROGRAMMING AND SKETCHING HAS TURNED HIM INTO A SOUGHT-AFTER ANIMATOR. SIMILARLY, ERIC NATZKE USES STARTLING IMAGERY AND TYPE IN COMBINATION WITH EXPER-IMENTS SIMILAR TO THOSE FOUND ON CODING SITES.

THOUGH EXPERIMENTAL SITES OFTEN FEATURE EYE-CATCHING WORK, THEY ALSO SIT AT THE EDGE OF TECHNOLOGY AND ARE USUALLY AS INTERESTING TO PROGRAMMERS AS THEY ARE TO DESIGNERS.

/RIGHT AND NEXT PAGE TOP LEFT

One of Natzke's many "variable typography" experiments, this one takes any text you like and uses masks to split it along a horizontal axis. The results are the same as if you had taken a printed phrase, cut it the long way, and pushed the strips in different directions over the photograph.

/LEFT

The homepage to Natzke's site is itself an interface experiment. The small cubes each correspond to the different projects in the site's archive. They can be moved wherever you like and turn red when clicked. That allows you to organize the interface to suit yourself.

/INTRODUCTION

It's hard to know whether to be impressed or appalled by Natzke.com. Not that it indulges in the risqué side or has questionable views on this or that. Rather, it seems to require such a pile of work that it's hard to imagine Erik Natzke having time to develop views on much of anything.

"I try to think of what time I spend not designing or thinking about design," he says, "and I guess I don't spend much time doing anything else."

The fruit of that obsession is Natzke.com, a never-ending sprawl of experiments that grows out of his unique method of posing questions and answering them.

/BACKGROUND

Though few designers name their personal sites after themselves, such a quirk seems almost natural for Natzke. He is as unlikely a design hero as ever strolled the planet.

Growing up in Thunder Bay, Ontario, Natzke happily fell under the category of "would do better in school if he applied himself." He was much more into his own thing than in hitting the books. He was an inveterate tinkerer, a terror to every old radio in his garage. His parents were also into arts and crafts, and they taught him to carve wood and work with fabric.

But if his upbringing was generally artistic and technical, it was short on graphics and computers. At around 6'4", Natzke's main interest was sports. He red-shirted basketball at Milwaukee's Concordia University, and found design only when he became disgusted with a manual in an anatomy class. So disgusted that he decided to spend the summer redesigning it and, in so doing, discovered his talent for illustration and desktop publishing.

Natzke has a habit of not finishing schools, so he traded Concordia for the tacky lights of Las Vegas. There, he came into contact with the Web and its designers and saw that they were churning out huge numbers of personal sites. The idea of a cheap and unlimited source of publication appealed to him, and led him to enroll in the Milwaukee Institute of Art and Design (MIAD).

After adding MIAD to the list of schools from which he has not graduated (ten credits short), Natzke decided to go into business with a few friends—mainly because he wanted to work somewhere where he could continue to grow as a designer. Their company, Forum Design, was set up simply to provide them with the financial support they needed to pursue their personal work. "I pay myself about as much as a Taco Bell manager," says Natzke.

His main creative outlet is Natzke.com. The site originated as a series of studies done in early 2000 and has grown into a respected experimental platform. Other designers flock to it, not only for the technical competence of its coding experiments, but also the striking imagery that comes along for the ride.

VARIABLE TYPOGRAPHY 2.0

THIS STUDY OF VARIABLE TYPE USES MASKING AND ACTIONSCRIPTS
TO ENLIST THIS TYPOGRAPHIC TRANSITION.

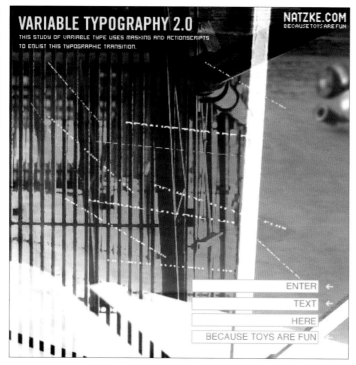

VARIABLE TYPOGRAPHY 2.0

THIS STUDY OF VARIABLE TYPE USES MASKING AND ACTIONSCRIPTS
TO ENLIST THIS TYPOGRAPHIC TRANSITION.

NATZKE.COM
BECAUSE TOYS ARE FUN

ENTER ←
TEXT ←
HERE
BECAUSE TOYS ARE FUN

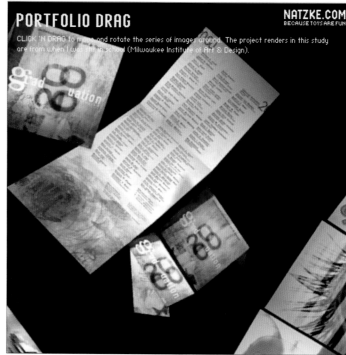

PORTFOLIO DRAG

NATZKE.COM
BECAUSE TOYS ARE FUN

CLICK 'N DRAG to move and rotate the series of images around. The project renders in this study
are from when I was still in school (Milwaukee Institute of Art & Design).

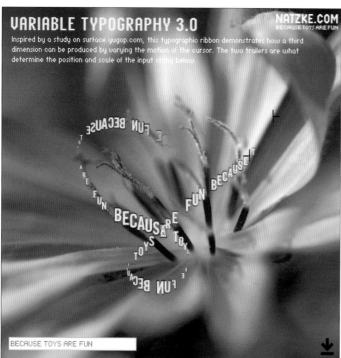

VARIABLE TYPOGRAPHY 3.0

NATZKE.COM
BECAUSE TOYS ARE FUN

Inspired by a study on surface.yugop.com, this typographic ribbon demonstrates how a third
dimension can be produced by varying the motion of the cursor. The two trailers are what
determine the position and scale of the input string below.

BECAUSE TOYS ARE FUN

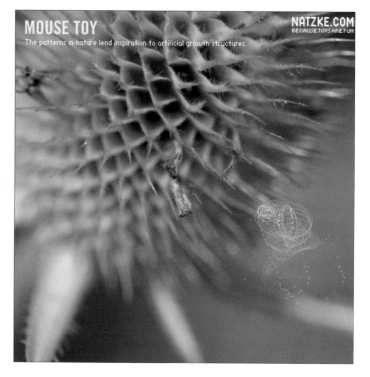

MOUSE TOY

NATZKE.COM
BECAUSE TOYS ARE FUN

The patterns in nature lend inspiration to artificial growth structures.

/BELOW, LEFT

This typography experiment will take any text you type in
and swirl it around in a helix fashion. Notice how the word
fun has been wrapped around so its back is facing the
viewer. Of particular interest is the flower Natzke has put
behind it and how it mimics the shape of the type.

/ABOVE, RIGHT

When you click and drag your mouse across this image,
the different pictures all revolve around a single axis.
However the axis is much larger than the screen itself, so
some things spin off, while new ones move in. The exper-
iment, which uses art from Natzke's school portfolio,
required a lot of work with mouse detection and a script
that drove the rotation of the pieces.

/BELOW, RIGHT

Here, Natzke mingled nature and a script intended to
mimic it. The small, green whirlpools at right actually only
come into being when you move the mouse across the
screen. As you do this, green lines spill off it, swirl away,
and disappear.

/CONTENT

It's hard to separate content from technique in Natzke.com. The site mainly concerns itself with problems, but not political or emotional ones. "Does it have a point it's trying to prove?" Natzke asks. "Probably not. For me, the point of an exploration is not to resolve anything large or concrete. For things to evolve, you just want them to go in a direction."

And that direction, at least, is clear. Natzke constantly explores what he considers the building blocks of Web design: interfaces, transitions, photo manipulations, and typography. Within each of these, he discovers little things he wants to know. For example, how can you make an image dissolve with a watery effect when you drag your mouse across it? How can you transition between pages by cutting your backgrounds into squares and animating them into place? How can you produce type effects based on words entered by a user?

If the problems are similar to those on other coding sites, the execution is far different. Most scripting experiments don't worry about imagery. They feature empty windows and blank interfaces to draw attention to the functional aspects of the piece. But on Natzke.com, you'll find startling close-ups of flowers, wide panoramas of lakes at sunrise, and snowflakes falling on the iron bars of a downtown fire escape. In an experiment on the effect of wind equations on an interface, Natzke set the usual dots and lines against a picture of a deserted winter field, with dead stalks of corn bent over by a storm.

This mingling of design and code can easily be seen in a piece he did for *Born* magazine. There, he set out to make a visual interpretation of a poem by Chris Green called "Walking Together What Remains." His initial idea was to take a series of pictures and arrange them like the blocks common to American sidewalks. Natzke assigned each line of the poem a different block and decided to animate from one to the next. Then, he hit on an idea. What if he knit the poem together using a trick based on the letters in each line? If one line shared a few letters with the next, he wanted to leave those letters in place, and animate the new line in around them.

To do the transfers, he wrote a script that would pluck certain characters out and throw them in a swirling mix of letters from the next before settling them down again. It was a problem worthy of any coding site, but it was done for *Born* magazine, which is an artistic forum, and as such it had to look good, too.

In other words, the problems that Natzke sets for himself go beyond code. They are whole environments, where scripting and visual questions are answered side by side. It's a combination that gives Natzke.com its uniqueness, and ensures its following.

/TECHNIQUE

Because Natzke.com presents so many solved problems, it gives the impression that its proprietor is a fellow who thinks up a project and works like a dog to finish it. Nothing could be further from the truth. At the core of Natzke's creative process is something his friends call "tangential velocity." The more he gets involved in one project, the more likely he is to fly off onto another.

He puts most of his creative emphasis on avoiding problems that someone else has tackled before. Partly, he can do this because of the visual nature of his experiments, but he also tries to stay away from the methods common to hard-core coders, like surfing the Web and wondering how something or another was done. "I always want to find a truly unique concept," he says.

To do this, Natzke thinks continually about his site: when he's driving, when he's walking to get a cup of coffee, when he's talking to his parents on the phone. He reckons that he spends almost all his time either thinking about design or talking about it, and believes that this total focus is necessary to be creative with his scripting experiments.

Again, though, Natzke doesn't advocate a methodology based on total concentration on a single problem. In fact, he normally keeps at least forty unsolved projects in his mind at one time. "I solve them just by allowing them to sit around for a while," he says, "I know that while one sits there, I'm playing with it, and eventually, I'll solve it and implement it."

One advantage of doing this is that solving one problem often helps you solve others. Early on, for example, he wanted figure out how to make an online version of the game Pong. He knows now that it only takes about five lines of code, but for a long time, he couldn't figure it out. The solution occurred to him much later, after he'd been working on a much more complex project for a while.

The vast majority of Natzke.com problems have to do with coding, which is hardly a surprise. Natzke left school in 2000, a date that puts him into the class of designers who learned scripting side by side with typography and visual design. He is used to thinking through math and imagery at the same time, and his solutions are lush with references to *xy*-coordinates, mouse relationships, and geometric formulae.

When he finally finishes thinking through a problem in his head, the actual production time is quite small. "I usually figure everything out beforehand," he says, "and then I just do it." Occasionally, he will have a happy accident in front of the monitor, but anyone who's familiar with the precision of his experiments knows how rare this must be.

Overall, Natzke.com is a real hybrid, a mix of technology and art in equal parts. To produce something like that requires a good eye, a limited social life, and a slavish work ethic. Luckily, Natzke has them all.

In two years, the outside world will probably decide that that Erik Natzke has become something entirely different. "I could end up a guy who just does code all day long," he admits. His ability to completely absorb himself in far-off projects and ideas does tend to ensure that he'll be moving in some direction far from the one he is in now.

In terms of the big picture, Natzke is sure that he and Natzke.com will be doing the same things for a long time to come. "I can guarantee it's going to be an exploration," he says, "but where I'll explore, I don't know. If I find a new area, I'll go into it. There's no rigid structure with this."

PARKING VIOLATION NATZKE.COM BECAUSE TOYS ARE FUN
This fluid distortion is accomplished with 40 masked layers, an x,y mouse relationship, and a name based lag script. The image is a tribute to the two parking tickets I received last week. The utilization of a collage resulted from constant pestering by Nando to open Photoshop more.

MULTI-MASK DISTORTION NATZKE.COM BECAUSE TOYS ARE FUN
Click / Drag / and Release to set in motion.

/LEFT
...

Don't like your parking tickets? Well, neither does Natzke. When you first open this experiment, each of these images, which are real parking tickets Natzke has collected, starts out whole on the page. Then, when you click and drag your mouse, they animate into this swirling, staggered effect.

/RIGHT
...

Watery effects like these are not the easiest thing to produce in Flash. The background photo here is a close-up of a leaf. However, when you mouse over it, the leaf is lost in a tide pool of distortions of itself. The end result is a rotating, liquid like mass of green.

PARTICLE GENERATOR 1.0
CLIP DUPLICATION - BEHAVIORS - RANDOM DISTRACTIONS

ROTATION	65
PARTICLES	87
ALPHA	35
XSCALE	77
YSCALE	79

/ABOVE

Here Natzke created a pen that spewed colored transparent
squares. As you move your mouse point across the screen,
these squares tumble out and fall down toward the
bottom of the screen. The interface allows you to change
both colors and shapes.

/TOP AND OPPOSITE

These images show the responsiveness of Paterson's programmatic pens. The larger shapes came from moving the pen more quickly; the smaller ones from drawing it along at a slower pace.

/INTRODUCTION

When tools like Photoshop first came out, the oohs and aahs quickly turned to hard-nosed questions about how this or that image was done. Book after book focused not on the designers who had produced the work, but on the software cocktails they had used to do so. Then, a backlash developed, and people began insisting that they were responsible for their graphics—and not their computers.

Nowadays, there's a new generation, and one that seems more at ease with progress. Case in point is Canadian designer James Paterson. After a lifetime of sketching on paper, he's discovered the computer and admits it's changed the way he looks at drawing. And he believes that's a good thing.

Paterson's main production is Presstube, an odd little world where minimalist figures dance around to techno music, thousands of lines race across the screen, and blobs of color form and reform. But its biggest hope is to push the very idea of what it means to draw.

/BACKGROUND

When you meet him, James Paterson looks like every other young kid with a strained relationship with the great outdoors. His hair is tousled, his T-shirts small, and his pants large. He travels the world talking about Web design and has no idea what he will do when he grows up, if he ever does.

But if Paterson were caught on a desert island with nothing but every sketchbook he'd ever filled, he would not lack for fuel. He normally keeps a pad and pen on him at all times and hauls them out whenever he has a spare moment to trace a figure or two.

Paterson started sketching because he thought it would be a good way for a shy kid to meet girls. Of course, he was mistaken, but it did lead him to fill thousands of pages first with realistic pictures of people, then with minimalist figures, and finally with wholly abstract swirls of lines and color. By now, drawing has become more than a hobby or a career for him; it's pretty much the way he sees the world.

Paterson's talent led him to the Nova Scotia College of Art and Design. There, he met fellow student Martin Spellerberg, who was interested in the cheap publishing possibilities on the Web. In 1997, Spellerberg launched an online community called Half Empty, and soon Paterson found himself learning to code HTML and make his sketches dance to music. In 2000, he broke off from Half Empty to do a project called Presstube with friends Eric Jensen and Robert Cameron. Its initial issue focused on a drawing exhibition they had done together, but the site has since turned into Paterson's personal playground.

These days, Paterson has taken the money he's made so far on the Web and moved back to Canada to spend a year working away on Presstube. "There will be lots of updates," he promises.

/CONTENT

To call Presstube a sketchbook is really to stretch the word to its present day limits. In the past, "to sketch" always meant to draw something quickly. You sketch out plans before you make them, and when you sketch a building, you draw its outline. But sketches are rarely serious. Picasso may have sketched brilliantly, but no one trains the monocle on his sketches as carefully as they do on his paintings.

Even so, Presstube could not be more dedicated to the form. Much of what you can see on the site is, in fact, selections from Paterson's sketchbooks, nicely arranged with zooming buttons. Still more are drawings that began as sketches and later acquired some color on the computer.

But as he has learned more and more about programming, Paterson has tried to push the idea of what sketching is. He's developed a number of different drawing tools and even created a special section of his site (called "interactive") where you can play with them. Click on one and drag your mouse across the screen, and you may find that you're drawing not with lines, but with squares, or even with little red figures that jump around and fade away. Move faster and the output may become larger and more spread out. Concentrate in one place, and the "point" of the pen may shrink down to nothing.

Naturally, Paterson uses these tools to come up with some surprising things. Many of the more complicated pieces on his site have actually been created using programmatic drawing tools that throw patterns of squares or lines. In these, Patterson usually shows his excellent sense of composition, which has grown out of the many thousands of pages he's filled with his drawings.

The site possibly becomes most interesting when Paterson works with an animation engine he developed with programmer Amit Pitaru. The result is a wildly rich animation style, almost complex enough to seem organic. The odd, headless figures play among flying scraps of lines and color. They grow, they shrink, and sometimes they eat each other. "A lot of what I'm doing," Patterson says, "is to take the cold world of the computer and come up with something living."

Since much of what Paterson does ends up on Presstube, the site has become a great place to look over his shoulder as he works. Sketching may not be the art form taken the most seriously in the world, but it is one where progress is being made, and it can be watched daily.

Animation | 2D | Interactive | Downloads | Links

→ new section @ PT.
→ now a download menu for your
→ desktop and screensaver needs.

→ for right now all of the downloads
→ are for PC.
→ the desktops are for 1280x1024

▶ enjoy :)

✳ (email)

☑►James P
☑►robbie c
☑►eric J

1---Tranquil - 5
2---Warfine-2
3---Pofen - 600
4---Mucular
5---Veetids
6---Glyburide
7---Flunkazol
8---Uriflox - 400
9---Lactoxam Plus
10---De - Vomit
11---Bismul
12---Norvek
13---Email James p
14---Enter PT

/ABOVE

This wildly colorful interface shows the influence of graffiti art warped through Patterson's busy pen. It is actually intended as a free desktop giveaway, and is available off the site.

/LEFT

Here is a mingling of sketch and Web. The original sketch-book was done in pen and ink, but the Web interface is mingled seamlessly over the top. When clicked, the menu bar at the top animates away much like a slinky being ripped off the side of the screen, and another image is loaded before the menu sweeps back in place.

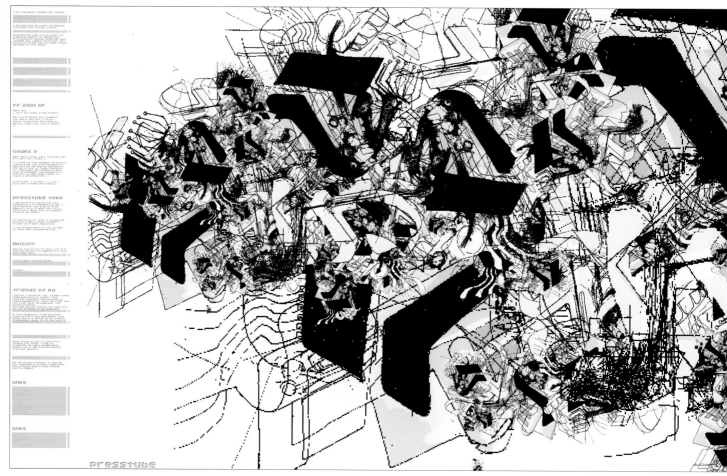

/ABOVE

This piece demonstrates how the colored sketches in Paterson's layouts are not independent of their place in the interface. The play of solid blocks of color with lines builds the basic composition of this piece, but the use of the yellow-green colors draws the sketch into the menu bar at the left.

/TECHNIQUE

There are those who dash things off or deal with problems that arise in their creative work by taking a break. The other method, and the one that's more rare, is to grind away at the difficulties until a breakthrough comes, and it's to this flag that Paterson owes his allegiance.

He feels that continual work is what gives his personal site its singular style. "If you sit down inside your own head, you make discoveries," he says, "You get further and further away from what you've seen before." In other words, you eventually enter your own little world and develop your own language. To get there, Paterson draws incessantly, both on the computer and off.

He takes a similar approach with his exploration of coding. He first learned to program HTML years ago, but he really got interested in scripting when it became available for Flash technology. He spends much of his time now working with code and trying to figure out how it can help him push his drawing style.

Even that, he admits, has not been enough. Though he has created the programmatic pens that help along his sketches, a huge part of Presstube has come from teaming up with others. "At first, I thought I knew a lot about code," he laughs, and then he started to meet people who knew more. One of the most fruitful of his

What appears first to be a splatter of color across the bottom of the screen is carefully balanced by a mirrored and muted version of itself centered in the opposite corner of the layout. The careful composition keeps in check what might be otherwise a chaotic screen composition.

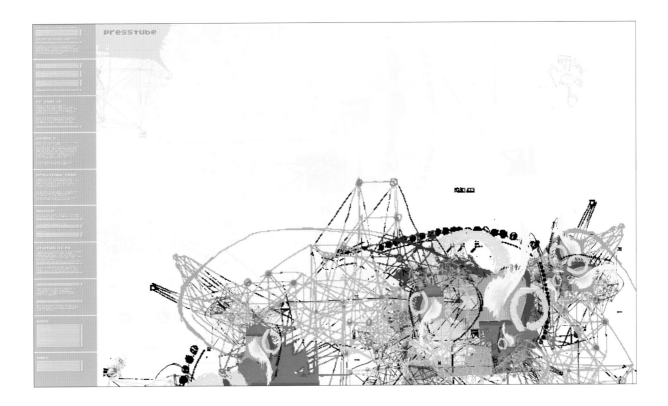

collaborations has been with a jazz musician and programmer by the name of Amit Pitaru. Pitaru has developed several animation engines that run on top of Flash.

The tools work much like a music mixing board, except the basic elements are drawings, not snippets of sound. They allow Paterson to take a certain figure and quickly test different animations with it. Using sliders, he can change variables to get different results, and though the tools naturally come with huge limitations in the kind of movement they allow, Pitaru tries hard to adapt them to what Paterson needs.

Such a working relationship is an excellent recipe for originality. It begins with a particular artistic vision, namely Paterson's sketching. The sketching is then interpreted by Pitaru, who does so by developing a tool to serve it. Then, Paterson figures out the tool, reinterprets his own vision according to how it works, and what it lets him do. The end result is almost certainly going to be something different from anything anyone else has done.

"Technically it's a ton of trickery made easy," Paterson says, "but you have to learn these tools and then leave them in favor of inspiration. It's like taking crazy code and throwing a saddle on it."

In other words, what drives Presstube is a dialogue between scripting and drawing. Some of it grows off the interplay between Paterson's always developing programming skills and his new ideas about sketching. But more interestingly, it works by mingling his visions with the sophisticated coding of others.

/THE FUTURE

Paterson is still a young and developing artist, and what will become of all this work remains to be seen. In the near future, he's planning on opening a collaborative site with Pitaru at http://www.insertsilence.com, and he's also committed to a heavy update schedule.

Whatever happens, nothing will probably change Presstube's most important ingredient—the peculiar way that Paterson sees and interprets the world around him. Without that, the rest of it all wouldn't be the same.

/LEFT
..

Stuffing a teddy bear into a scanner and then digitally removing its face made the central image here. The shapes along the bottom, Benjamin notes, are entirely meaningless, but gain some kind of interest due to their repetition. He also assures us that the bear was not harmed by its ordeal.

/OPPOSITE
..

The comical illustrations and layers give this tiny GIF image are classic Superbad, an attempt to get the most interest out of the least bandwidth.

/INTRODUCTION

Though it doesn't step on any toes, Superbad is no stranger to controversy. Some designers say it's one of the best personal sites on the Net, while others ask what cat brought it in, and how they can get rid of it.

But whatever designers think, there's no debate about the site in the fine art world, where the black turtlenecks have adopted it as one of their own. They love that it's not about bandwidth or technology. That it doesn't ooh or ahh. That it isn't hip or cool. That it just sits there and plays with a single question: How much fun can you have with next to nothing?

/BACKGROUND

When Ben Benjamin was growing up in Indiana, he often told people he wanted to be an artist. Their reply was unanimous: "How's that gonna make you any money?"

Of course, Benjamin knew they had a point. Most artists either starve or have trust funds, and, since he was somewhat short on trust funds, he decided to study psychology at Earlham College, a Quaker school not far from home. There, he developed a pleasant working personality for a designer—patient, humble, and always willing to chime in with an interested comment. But by the time he graduated, he was convinced—starvation be damned—that he had to do something artistic with his life.

He decided to try advertising and moved to San Francisco to study design. Then, the dot.com craze struck and brought with it its voracious appetite for talent. Every kid with a sketchbook was platooned into making interfaces, Benjamin among them. His first job was an internship at CNET, but he quickly broke off to form his own freelance company, Mister Pants, and has worked around the world ever since.

The concept for Superbad came to him soon after he joined CNET. Even in those days, the Web had a lot of rules, and Benjamin wanted to see if he could break some of them and still make a fun site. So he nabbed the Superbad URL and began building crazy interfaces based on funny images.

Currently, Benjamin works as a freelancer in Los Angeles, California, and continues to update Superbad on a regular basis. He has a lot of fun with it, though it still refuses to make him any money.

/RIGHT

This small piece, known as "Patriotic Pipe," is probably the only piece of artwork around that mingles a section of PVC pipe with an image of Uncle Sam. This page also serves as a navigational element: By clicking on different radio buttons you can move to different parts of the site.

/BELOW RIGHT

Chairman Brand is really a stylized portrait of Mao Tse-Tung, who holds a peculiar fascination for Benjamin. He points out that the leader used his image in ways similar to Western branding.

/CONTENT

No matter how much people may like Superbad, most find it surprising that Benjamin is actually an accomplished designer. The site's blocky images, weird shapes, and clashing colors often look like the work of someone who should be separated from the field with razor wire. But, then again, since the site's real purpose is to turn design and advertising on their heads, the look isn't so surprising.

"I'm trying get the absolute most visually and interactively, the largest experience through the thinnest bandwidth," he says.

Pop Superbad open, and you'll notice its dominant characteristic—the lack of an interface. Instead, you'll get a GIF image. Click on it and you'll go to another. Click again and you'll go to a third. And so on. In all, the site has nearly three hundred pages full of all sorts of things: scans of stuffed animals, bits of signage, old magazine ads, and strange products found around the world.

And much of it is a good time. For example, the site is fascinated by long-dead advertisements and "mistakes" in design. Heading the list of the first category is Colonel Sanders, who gets in because he sells an awful lot of chicken for a dead guy. Benjamin also loves to play with Mao Tse-Tung, because he managed to become a brand in a country that officially had outlawed them.

"It's trying to get the most fun out of the thing," he says, "I take an image and distill it into the one thing that's most fun."

Another way it does this is by placing a decontextualized focus on design itself. Much of the work in this category is built from rejected comps of actual work. A frame for an illustration may become the focal point for an entire page (sometimes with a smiley face put in the middle of it). Or he may take the outlines from a circular color study and turn it into an entire layout. By doing this, and redesigning it for the more lighthearted purposes of Superbad, Benjamin hopes to draw attention to what we'd normally forget.

In its happiest moments, Benjamin's site is all about taking very small images and bringing them out for a bit of enjoyment. "It's often things I think are nice," he says, "but not anyone else really thinks so."

This mingling of colors, architectural drawings, and what appears to be a griffin, makes an interesting game of "What-was-he-thinking?" It actually comes from a series called Assyria, which used imagery from that ancient culture.

/TECHNIQUE

Superbad is hardly a technical marvel, but maybe that's the most interesting thing about it. For almost all of its pages, Benjamin sticks to a 30 K page limit, which is a huge sacrifice considering that the most conservative Web pages, those for Fortune 500 companies, have a 50 K limit. Superbad does have some JavaScript, but generally treats plug-ins like plague victims.

The site is mainly made of tiny bitmapped images, and it doesn't bother with interfaces. To get through it, you simply click one page after another in a never-ending tunnel of content. However, don't expect to find the same tunnel every time you enter. In fact, the site contains many different forks. Different images on a page have different links, and direct you down different paths, so that it's very hard to remember how to get to any specific screen in the site.

To come up with the pieces, Benjamin relies on the world around him. He tends to pull in strange designs and advertising he has seen around the world. On top of that, much of what appears in Superbad is material that he would like to use in client projects but can't for whatever reason. They may come from rejected designs or parts of projects that didn't get used. He also admits that he sometimes even mucks-up a comp so he can use it in Superbad.

Once he's designed a new image, Benjamin simply throws it on top of the rest and links it to something already there. Though this is a marvelously efficient way to build a site, it does introduce a navigation problem. If you click from screen to screen, naturally, you just move back farther and farther into time. You quickly end up on old stuff, and have a hard time finding your way back to anything that's been added recently. To check this, Benjamin has created a few gridlike pages that let you move to any place in the site. Often they are made up of radio buttons that seem to have no function, but when activated, they change whatever links there are on the page.

Beyond this, the site does play quite a bit with Easter eggs. Experienced Superbad fans know they should always pop open the source code and see if there is something special to click through: a hidden screen, or even just a joke or message that has been commented out. Another fun thing to do is to access the directories on the site (you do this by pulling the last element of the URL off and reloading). There you can often find more images or messages.

The end result loads very quickly and provides fast navigation. If you don't like or don't understand an image, it's not a problem; there's probably something that's a lot more fun just around the corner. In all, it's not a bad way to spend an afternoon when you should be working.

/THE FUTURE

Since Superbad is based on solving problems in a specific set of rules, it's not surprising the Benjamin has slowed in his production of the site. Where he used to work on it all the time; now it will only occupy a few days a month.

Still, the well-developed personality of the site, and Benjamin's interest in and understanding of its rules continue to make it an old friend of his, and he promises that he'll continuing working on it as long as it stays fun...which it seems to be doing.

EXPLORATION

AS WITH MOST CATEGORIES, "EXPLORATION" IS NOT TERRIFICALLY DESCRIPTIVE. MOST PERSONAL
SITES EXPLORE, BUT THEY USUALLY DO SO IN THE SERVICE OF TELLING A STORY, EXPLAINING
A FEELING, OR INFLUENCING THE WAY WE LOOK AT THE WORLD. HOWEVER, THERE ARE SOME
SITES THAT MAKE EXPLORATION THEIR WHOLE RAISON D'ÊTRE, WHERE EACH PIECE REPRESENTS
THE RESULT OF A LONG CREATIVE INVESTIGATION INTO SOME ASPECT OF DESIGN OR CULTURE.

SUCH SITES ZERO IN ON A SINGLE TOPIC, WHICH MAY OFTEN BE IDIOSYNCRATIC. MIKE CINA,
FOR EXAMPLE, HAS TURNED HIS TRUE IS TRUE INTO A MEDITATIVE ROMP THROUGH FORGOTTEN
IDEAS. DAVID YU'S DHKY INSTEAD LOOKS AT HOW SHARDS OF ASIAN CULTURE HAVE BEEN
REAPPROPRIATED IN AMERICAN COMMERCIAL ART. AND MAYBE STRANGEST OF ALL IS
THREECOLOR, SPENCER HIGGINS' MINIMALIST STUDY OF FORM AND MOVEMENT.

ON THE WHOLE, EXPLORATIVE SITES TEND TO BE CAREFUL AND REFLECTIVE. THEIR IDEAS,
WHILE OFTEN DRY AND INTELLECTUAL, ARE NONETHELESS EXPRESSED IN A CLEAR VISUAL
LANGUAGE THAT MAKES THEM AS INTRIGUING AS ANYTHING ON THE NET.

/THIS PAGE

Much of Mercier's work builds off of upward-looking photography, several different crops of the same photograph, and his travel photography, as seen in these covers.

/OPPOSITE

Take a photo from under a crane and flip it at 180 degrees, and you get the main feature of this cover. The sectioned field of color to the left provides structure to the photographs, as well as margin if they are ever published as a book.

/INTRODUCTION

When Arnaud Mercier dropped into a Vancouver café one day to talk about Elixir Studio, life's cares seemed to be ganging up on him with baseball bats. He had designs to do, speeches to write, and a birthday party to organize.

Normally, none of that would matter in a discussion about a personal site, since most of them are published on flexible schedules. But Mercier has set up Elixir Studio as much as a challenge as a vehicle for personal expression. He has promised to build a new cover for it every two days until he's made one hundred of them. And everything else is supposed to take a number.

A1

A3

B1 B2 B3 B4

C1 C2 C3 C4

APRL
20
updated

D1 D2 D3 D4

E1 E2 E3 E4

THE WORK OF
ARNAUD MERCIER

e5

F1 F2 F3 F4

<ELIXIR_STUDIO> 097

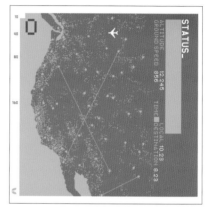

/THIS PAGE

This Flash movie, titled "Journey," was a natural for the well-traveled Mercier. Its sequences were almost entirely composed of photographic pans mixed with graphic animation overlays.

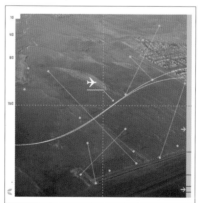

/BACKGROUND

A native of Lille, France, Mercier had originally wanted to be a movie director but he didn't have the patience for it. In the French film industry, as in others, artists battle their entire lives for state-sponsored grants and can only do their own projects after a lengthy crawl up the creative ladder.

After a short time in the field, Mercier began looking for a way out. He soon found it in the work of No Frontières, a Viennese art collective that had produced one of the first books of artistic Web design. The young Frenchman saw they were on to something. Web design was a new field, where no one had seniority, no one had connections, and everyone was on an equal footing. To get ahead, all you had to do was be better than the next guy. So he quickly learned technology and entered some work in a contest for young creatives. He won, and that made it possible to open a small design firm called Elixir Studio.

Elixir Studio provided a living, and gave Mercier time to explore the highly mobile Web design culture and its emphasis on personal work. Soon, he decided to put up some more artistic designs on his site, and the work gained some notice. In time, he received a job offer from the French CEO of Vancouver-based Blast Radius, who had been trolling the Net for talent in his native country.

It was a job that turned out to be both good and bad. The projects were high profile and challenging, but Blast Radius was also a large firm, and its clients tended to have their own ideas about what they wanted. Again, Mercier found himself a cog in someone else's machine.

Luckily, he still had the URL for Elixir Studio and began to funnel most of his leftover creativity into the site. He works on it almost every day and even nurtures the distant hope of getting paid for it some day.

/CONTENT

It's hard to get around the fact that Elixir Studio is a two-headed monster. A singularly attractive two-headed monster, perhaps, but still not an easy one to figure out.

Its first and most visible half consists of its covers, which come newly minted every two days. Their dominant element is usually a photograph laid out on a grid that's made visible by lines or numbers. They are normally architectural studies: roofs stuck at odd angles, textures pulled from corrugated tin sheds, and shots that look upward at towering glass buildings. They are overlaid with text that gives the name of the site and the date of their production, and little else. It's easy to see them as pages in an inspirational book, not least because Mercier makes them at high resolution and with ample room for margins.

The other half of the site consists of interactive, filmlike projects. These are long, carefully plotted affairs, with photos, a soundtrack, and dozens of carefully arranged animations. Though the music is sadly the sort of French techno that most of the world keeps at the end of a long stick, it does seem push the graphic elements around, and that's no easy task on the Web. The projects vary in their format. Some, like his *Journey* are graphic films; others like *Subway* involve interfaces as well and are truly interactive.

Together, the movies and posters represent the two halves of Mercier's graphic philosophy. Though Mercier doesn't style himself a theorist like Jakob Nielsen and makes no claims to originality, he has thought things through, and his designs reflect that thinking. In the main, he feels that whatever you design must first fit the purpose it was intended for. But around its margins, you should also let your designer exercise a bit of creativity, and you shouldn't tell him or her how to do it. Making it cool is your job.

These ideas are not original, but at least Mercier practices what he preaches. In the longer pieces, the requirements of both usability and creativity are apparent. And both of them are there. But in the shorter pieces, Mercier has little or no use for an interface, and no message to convey. Instead, the covers simply show off what he calls the "creative element" in design. They're pretty pictures, pure and simple.

Together, the two halves, functionality and pure creativity, come to the fore in the site, and make it a quickly changing and worthwhile inspirational stop.

/RIGHT

Seen here is another Mercier cover of an upward-looking photograph of a building.

/TECHNIQUE

Putting out a new homepage every two days obviously requires a little set-up. To create the conditions for doing so, you need to already have a large bank of imagery on hand.

The main images that Mercier uses are his photographs, and it stands to reason that he is an obsessive photographer. One of his most-prized possessions is his own personal image bank of thousands of photos of every conceivable object. To do most of his quicker poster pieces, he simply selects a photograph and tries to crop it well, and throw a quick, creative, and effective design around it. His techniques here are fairly classical, generally employing grids and well-laid type. He sets himself a time limit for each piece, a short twenty minutes.

For longer pieces, Mercier uses a quite different method. Like most of those trained in film, he is a meticulous planner, and follows a rigorous process. The first stage is what he calls research and it consists of going out, taking pictures, and doing quick hashes of ideas. The goal of this stage is to gather enough of the visuals so that he knows the kind of assets he'll have to work with when he gets down to actually doing the project.

Next, he utilizes a pair of exploratory techniques as he tries to explore different visual directions for the piece. "Before I begin working like a geek, which is what I'll do next," he says, "I try working like an artist." So he makes a lot of rough sketches, always trying to get a solid concept down. After that comes technology, where he goes out into the geeky tools and figures out what's possible.

By this point, he still hasn't done any work that will show up in the final product. But with all his exploration done, he pretty much knows what he'll need to get. So he draws up careful lists of photographs, video sequences and music he needs, draws up a schedule and produces the project.

For some projects, things can get fairly elaborate. For one piece, he actually got permission for a three-day shoot in the Marseilles subway, and the authorities even turned the lights on after hours for him. That project was elaborately made and programmed, complete with its own music, photographs, navigation, and dozens of unique layouts.

So whatever he does, Mercier tends to work off a solid background of preparation, which frees him up to concentrate on the creative aspect of things.

/THE FUTURE

Elixir Studios was once simply a freelance site for Mercier, and it may return some day to that. But Mercier has done well developing his own style through experimental projects, and he shows every intention of continuing to do so. The final resting place for his one hundred page static designs project will hopefully be a book, and as for the rest, it will continue on as long as he likes doing it.

Subway was a project Mercier completed in Marseilles. It featured an interface built like a subway map and individual animations based on tickets.

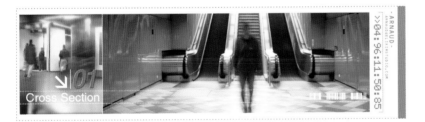

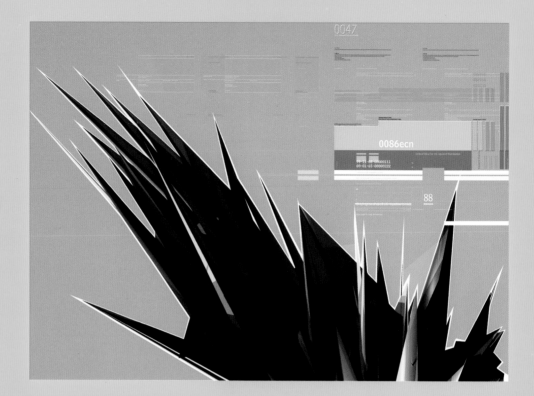

/INTRODUCTION

"I don't think I could ever live somewhere where I couldn't get up early in the morning and go fishing," says Mike Cina. It's not the challenge that appeals to him, the eternal war of wits between man and trout, but the peace, the solitude, and the contemplation of a pond at sunrise.

Those who visit Cina's True is True know how these quiet tendencies find their way into his work. Forget flashing lights, forget busy layouts, and forget loud colors: His site is a slow-moving, even mesmerizing take on personal Web design. You can measure some of its pieces by quarters of an hour, and others never seem to end. But every one shows the meticulous craft of a designer who rarely sets hand to mouse without a good idea of what's to come.

/TOP

Cina's experimentation with three-dimensional shapes dates back as far as 1995, long before the present rage. However, he abandoned it for several years in favor of his flatter, more Swiss-influenced style. With the recent resurgence of the style, Cina has sought to infuse it with the later lessons of typographic and structure, and both of these pieces show the imposition of that order on a more chaotic form.

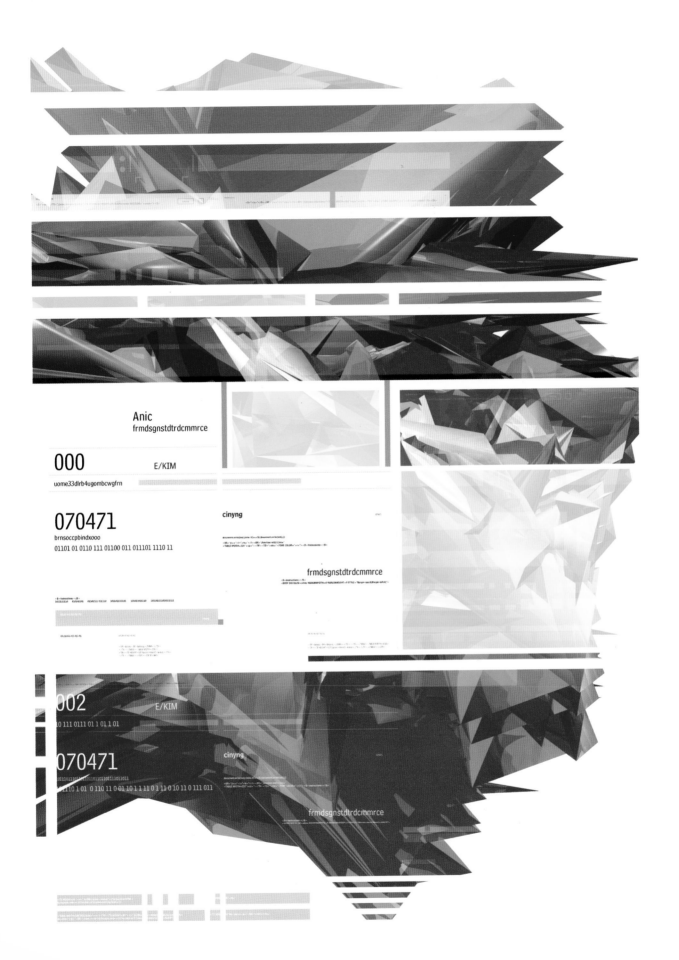

TRUEISTRUE.COM MICHAEL CINA 05.21.00 A4JC 123 FLASHMOVIE P1

/BACKGROUND

Mike Cina has spent the past few years in Eagan, Minnesota, a sub-urb of Minneapolis, where he lives from job to job, even if those jobs are for MTV and other well-known clients. Of course, big money beckons from New York and San Francisco, but Cina is stay-ing put. He's happy where he is.

There was once a different Mike Cina, one who never dreamed of parking his life in the suburbs. That Mike Cina was a design stu-dent Austin, Texas, who became a popular DJ. Throughout the early 90s, he tore up the rave scene (and his liver) at parties across the South. It was a twenty-four-hour-a-day existence that he lived to its last blurry cliché, including burnout and retreat. But eventually, he had his fill, and after a particularly rough night, he converted to Christianity and moved to Minnesota to find a less hectic way of making a living.

But whether partying or taking it easy, Cina has always had a remarkable nose for the spotlight. Though his first design job was for the Reverend Billy Graham, it didn't take him long to discover the then-thriving digital type scene. Soon, he joined forces with the celebrity type-designer Chank and put out a number of popular fonts.

The Web would be the next big thing, and Cina was there almost before everyone else. He first put up his own Cinahaus site and then hooked up with Matt Desmond and Joe Kral to make the Test Pilot Collective, a project that featured a new cover every day and a continuous stream of wild fonts.

In the summer of 2000, Cina decided it was time to strike out on his own. He quit his job, went freelance and launched True is True. With that, he finally has a creative space of his own, and one that reflects his slow-moving and easygoing personality.

/ABOVE, TOP

This piece is another of Cina's attempts to work with "triggered" animation. The leaflike shape and the lines running off of it were the result of Cina's interest in designing according to pattern set in nature. Clicking the small black handles sets off animations that proceed randomly.

/ABOVE, NEAR

The most ambitious of Cina's chaotic animation projects dealt with a world map. Click on one of the countries, and a series of abstract animations begins. Since you can never click two at the exact same time, your experience will always be different.

/OPPOSITE

This piece marked Cina's departure into a series of experiments using the theme of machines gone bad. The small, orange bars are actually the only buttons in the piece. They each activate animations that proceed at their own pace. They begin some time after you click, then start, stop, and continue at odd intervals. Click two and you'll have no idea which button triggered what animation. The design problem presented by this kind of work is immense: You must be certain that any combination of elements will look good together.

/CONTENT

Visual diaries tend to be bland, mainly because their creators tend to have the same visual thoughts over and over again. One day they see a pile of bricks in a construction yard, they take a picture, and they make a bricklike design. The next day they see a group of starlings in an apple tree. They take a picture and do a starlings-in-apple-tree design. And so on.

Cina's search for inspiration is happily not so passive. His site reflects his reading, and he puts a lot of time into finding books that no one else has read. Instead of the usual histories and design monographs, Cina haunts second-hand stores and pores through moldy atlases, architectural digests, and medical drawings from old encyclopedias. He might spend an evening with one of these books, and then think about it all morning while fishing. By the time he works it out on a computer, the result could be anything from an interpretation of a contemporary illustration style to a goof on Bauhaus architect Mies van der Rohe.

Though his sources of inspiration lie outside traditional design circles, Cina's style is strictly orthodox. He belongs to the Swiss school, and, as a disciple of Josef Müller Brockman, he takes a lot of time worrying about color, typography, and grid-based layout. He usually builds his designs off rectangular shapes, with deliberate animations and clear, legible type. However, in almost everything that goes up on the site, there is also a certain unpredictability. Cina likes his Web designs to seem organic, and achieves this by timing animations to take place over long intervals. If you click on a trigger, the result may not appear for a while, and then may go dormant for seconds at a time.

For example, a book about natural design once prompted him to build a piece based on numerical patterns that occur in nature. The result was a leaflike interface that grew as you played with it. Each time you clicked a handle, you set off a complex animation that would slowly bring new parts of the leaf on to the screen, but chaotically and with lots of starts and stops. If you clicked two of these, you had no idea which one had caused what or when either of them was finished. "It's like a machine gone bad," he says.

In short, True is True builds visual interpretations of theoretical ideas. But wherever it wanders, Cina's sense of color and typography remain, and give it a constant backbone against which the ideas can play.

/TECHNIQUE

By this point, it should be clear that Cina is not the sort who does things randomly, who lets his creativity run hither and thither and then tries to make sense out of the results. "I think about things to death," he says, "the thought, the look, the execution. I usually don't start until it's mulled around in my head for weeks."

By the time he's done thinking about the project, he has it visualized completely: color, typography, spacing, and the rest. One thing he's particularly careful about is his use of music. Unlike most sites, where music is a garnish, Cina chooses his precisely to fit the piece he's designing. It must synchronize to points of the animation and suggest the kind movement that's taking place on screen.

But his biggest challenge lies in handling the chaotic results of his animations. Since Cina favors sequences that unfold over time and over each other, they require careful planning. The main problem is figuring out how to pick the right shapes and colors so that no matter what animation is triggered when, the page never looks bad. "In a lot of my work," he notes, "you can never get the same thing twice, because everything is timed independently."

Cina solves the problem by laying everything out in Illustrator long before he works with an animation tool. All the different animation elements go onto different layers, allowing him to test them by switching the layers on and off and adjusting the transparency settings. He normally spends a good deal of time trying to look through all the different combinations of design and color that can result from playing with the piece. With a lot of trial and error, it eventually tends to work out.

New versions of True is True usually come out twice a month. Ever since his work with the Test Pilot Collective, which featured a new cover a day, Cina has believed in a regular stream publication. True is True, of course, consists of interactive pieces and not static covers, and therefore comes out on a more reasonable biweekly basis. But the publication schedule forces him to continually move work out the door.

So, from inspiration to thought to execution, a True is True piece has a long life. But this process gives Cina a control over his personal work rare in a young designer, and it gives the site considerable strength that goes beyond that of most of its contemporaries.

/OPPOSITE
...

These images come from an animation that had no real point other than a desire to create something that transformed very quickly. All of these very different sorts of screens played their roll in it. The last image is of Cina himself.

/BELOW
...

Sometimes it's good to have a little fun for the new millennium. In one of his more elaborate projects, Cina added graphics and designs to an old atlas he had found. The results were shown from this interface.

/THE FUTURE

With his uncanny sense for picking up the next big thing, it's not surprising that Cina is often casting about for new avenues of creativity, and that True is True remains his testing ground for these ideas.

Cina's wish, naturally, is to do something like True is True full-time, though that dream has not quite come out of the sleeping stage. His commitment to his laid-back lifestyle seems to make it likely, however, that he'll continue on with the site and continue to haunt the woods at sunrise.

/INTRODUCTION

The most common complaint about personal sites is that they're pretty pictures that say nothing. Fair enough. Many of them are. But if you spend enough time on Spencer Higgins' Threecolor, you might learn that saying nothing can be a compelling way of saying something about design.

Instead of tales of lost love or anthems for social change, Threecolor treats its visitors to minimalist studies of form. In each of them, Higgins focuses on one tiny aspect of his craft, strips it of everything else, and tries to make something beautiful.

/BELOW

/BELOW

The movement of the body provides the backdrop for this striking study. Using figures colored only by monochrome gradients, the animation followed them though a striking number of combat sequences. Notice how nearly every sense of space, including the floor, is conveyed simply by the attitude of the characters and the white bands running along behind them.

/BACKGROUND

Growing up in Houston, Texas, Spencer Higgins' first love was photography, and he got off to a quick start in the field. While only a teenager, he worked the sidelines of Oilers and Rockets games, taking pictures for the local newspaper. But if sports photography liked him, he didn't like it, and he ended up in a New York art school (whose name he doesn't like to give out), where he became interested in new media.

After graduation, Higgins won an artist-in-residency slot at the Italian art collective Fabrica, which was one of the few places at the time that actively promoted art on the Web. There, he learned a lot of things, not least that if you sit all day in front of a computer, your rear end gets sore. But more importantly, he learned that Web design was pretty much his career. When he returned to New York, he started working on complex sites for large, corporate brands and he's done it ever since.

Given that his clientele is fairly straitlaced, it's not surprising that Higgins has also launched a personal project. He uses Threecolor as a space totally different from his commercial work, a place where he can explore themes and ideas without worrying about pitches and deliverables.

Though the site has now been around several years, Higgins has yet to take up the bullhorn to get publicity for it and probably won't. Instead, he prefers to keep it for himself and let people find it if they can.

/CONTENT

The day-to-day solutions in graphic design are contextual. At best, they take type, color, and imagery and use it to say something like, "Sterling Anderson spigots are spigots you can trust."

But if you put a magnifying glass very close to an excellent design, you can sometimes pick out the pure beauty of a single letter or follow a graceful line as it sweeps through a composition. Perhaps you'll find a well-turned gradient, or a series of numbers on an impeccable grid. These little elements are what Higgins calls forms, and he's made them the subject matter of Threecolor.

The site's usual stage is a plain white field, and its cast of characters a stream of elements that have been painstakingly detached from the world. One whole project may consist of a font, or even just a few letterforms. Another could grow out of a special kind of

/BELOW

This study of abstract letterforms shows Higgins at his minimalist best. The three-dimensional letters combinez with one another in a surprisingly intimate, and ultimately meaningless ways, placing the focus entirely on the type itself.

motion Higgins has observed, for example, the way a certain person shuffles his feet. Usually, though, the pieces on the site will involve more complex forms, like the shape of a building or the movements of a pair of kung fu artists.

"I've branded Threecolor in a certain way," Higgins says. "I'm not going to deal with social issues; I'm going to deal with one specific aesthetic and it happens to be minimal."

Of course, if Higgins produced nothing but a stripped-down form, it would be dull, a bit like sitting in a bus seat without having a bus attached to it. So Higgins does greatly enhance the forms before publication. A certain kung fu kick that was the point of the original study might get invested with a storyline. A font may take on a three-dimensional shape, and a line may get traced against an interesting photograph. If the final pieces remain quite minimal, they're not utterly bland.

But Threecolor is more than a simple experiment in formalism; it also serves as a commentary on other personal work on the Web. Whereas many of Higgins' contemporaries use their sites to extend themselves into different styles, Higgins tries to remind them all that at the very bottom of everything is the form, which controls the structure of visual production, whether they pay attention to it or not.

The content in Threecolor, in other words, is a reduction of design to its barest elements and an attempt to work as close as possible to them while still making something worth seeing.

/OPPOSITE

...

A rather complex type of experiment, this piece sought to build flat letters by using large, complicated structures composed of many different blocks. Each one of the structures made different letterforms when rotated to show different faces. Since there were nine blocks, each with three different faces that could be read, the results allowed use of all the letters of the alphabet.

/TECHNIQUE

It's not so easy to flush out all the stimuli in your life and concentrate on a single thing. But Higgins is a skilled photographer, and he's found that focusing on an interesting design element is not far from looking for that perfect moment when a running back recognizes the dishonorable intentions of an oncoming linebacker.

Higgins begins each Threecolor piece by going through the world and trying to notice something. One of his biggest interests, for example, is athletic movement, and he actually spends a lot of time watching people playing basketball at the street courts in Brooklyn. There, he isn't just looking for the smallest possible movement and trying to isolate that. He's only interested in movement that contains an idea in itself and makes a contribution to a design. For example, the ordinary movement of a ball towards the ground would not be enough, but a dribbled feint that faked out a defender would.

When he's settled on a form, Higgins jots down a quick outline of the idea in a notebook. Then he retreats to the computer, where the learning process begins. He starts out with nothing more than the bare elements of the piece. If he works on a kind of movement, for example, he'll simply manipulate a circle of color. If it's a typeface, you can bet that no giraffes will come strolling on the canvas. And then he exhausts every possibility of playing with the idea, hoping that as he does, it will lead to something more. "Let's say you draw a circle twenty-five times," he says, "it will constantly evolve. This kind of process lends itself to finding other stuff."

When he is finally satisfied with his understanding, he returns to questions of color and imagery. The balls that have tracked along certain paths will acquire a more complicated shape, and perhaps Higgins will add type or a border.

Whatever he makes, however, has to be perfect if he's going to publish it. "As much as I personally work on tons of things for Threecolor," he says, "I'm not going to get eager and release everything. When I'm satisfied with something, I'll put it out, but this is a place where I can let pieces go and continue working on something else."

In this way, the designs manage to become the most minimal in the personal site world. The result is a simple statement, but not an empty one.

/THE FUTURE

Threecolor is one of those sites that only exists because its owner likes doing it. Higgins doesn't seem to care much about the personal site world and doesn't care if people like his contributions to it or not.

That is why there is every reason to believe that it will stay his formal playground for a while. "I really enjoy what I've been able to do on this," he says, "and most likely I'll continue with it."

/RIGHT

Like many images in DHKY, the "five deadly venoms" gently satirizes American culture's tendency to invent its own quasi-Chinese categories.

/INTRODUCTION

The reality of personal site building is quite messy. When most people launch themselves into a site, they have no idea where they're going or what they're doing. Instead, they play around for weeks and hope to find some ingenious post-rationalization that makes sense of all of it.

But for all the bad press it gets, this method is not half bad. Playing around with ideas and images can be a great way of finding out what you're really passionate about. And for David Yu, a Chinese-Canadian, that's meant picking out misappropriations of Asian culture and discovering the humor behind them.

/BACKGROUND

David Huk Kan Yu grew up in Edmonton, Alberta, on Canada's frozen plains. It was a long way from Hong Kong, where his parents where born and raised, and they gave Yu a home radically different from that of other Canadian boys. "We had Chinese music," he says, summing it up, "and all my friends were listening to Iron Maiden."

But Yu dealt with it well. Growing up, he excelled in school and eventually earned a degree in computer science at the University of British Colombia, and followed it up with a course in multimedia art. That led to a job at a large Web-design firm in New York City, where his ample programming and nascent artistic skills pushed him to the head of the class. Soon, he was working on sites for musicians and doing volunteer work for *Giant Robot,* an Asian culture magazine.

About the same time, he decided to start DHKY, mainly because he needed a place to experiment and develop design skills to complement his programming. He built whatever he felt like and was generally happy with the results. But after a while, he came to realize that most of the site's pieces made gentle fun of the way American pop culture incorporates Asian stereotypes.

The site now reflects that tension quite freely, both with collaborative projects as well as in the cover designs Yu does from day to day.

/OPPOSITE

The Chinese calendar, with its years named after animals, is a staple on placemats of cheap suburban restaurants. Yu's "The Year of the Rock" reflects his amusement with the emphasis American culture places on what is actually a minor feature of Chinese culture.

YEAR OF THE ROCK

為你生命披上繽紛色彩™
DHKY: FOR MORE BETTER LIFE ™

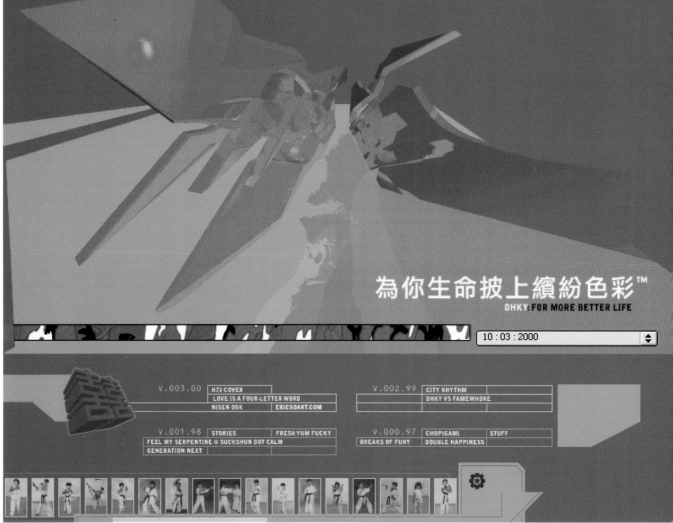

為你生命披上繽紛色彩™
DHKY: FOR MORE BETTER LIFE

10:03:2000

V.003.00 | H73 COVER
LOVE IS A FOUR-LETTER WORD
NISEN OSK | ERICSOART.COM

V.002.99 | CITY RHYTHM
DHKY VS FAMEWHORE

V.001.98 | STORIES | FRESH YUM FUCKY
FEEL MY SERPENTINE @ SUCKSHUN DOT CALM
GENERATION NEXT

V.000.97 | CHOPIGAMI | STUFF
BREAKS OF FURY | DOUBLE HAPPINESS

/ABOVE
...
The main interface of DHKY is a good example of how to
make a nontraditional interface work.

/RIGHT
...
Here, Hong Kong icon Bruce Lee gives a trademark menace
for the site.

/CONTENT AND TECHNIQUE

To explain the sorts of things he focuses on in DHKY, Yu tells a bizarre story. One day, while he was in a hip clothing store, he picked up a flyer for a rave party. It was obviously copied from a Chinese graphic of some sort, but whoever designed the flyer had no idea what it was. In fact, it was a death note, something Chinese people burn for their deceased ancestors on ceremonial occasions. The Western equivalent would be like using a tombstone to shore up a flowerbed.

DHKY tends to look for such misappropriations of Chinese and other Asian cultures and mine them for humor. For example, the site once featured a McDonald's ad where a Chinese Ronald McDonald mistakenly used a (Japanese) karate chop to get himself out of a difficulty. Another time, the site declared a "Year of the Rock" to poke fun at the American overemphasis on the Chinese calendar. "I'm not at all venting," says Yu, "but it's funny stuff I find."

To come up with the ideas for the site, Yu has to do little more than follow his own daily routine. As he watches movies or walks down the street, he'll pick up on some decontextualized element of Asian culture that's been recruited for use in American pop culture. "The way I work," he says, "anyone can do it. Everyone has their own history, their own life experiences, their own twist, their own way of doing things."

With content like this, it's not surprising that DHKY is simple to navigate. Many of the basic elements work off databases, and Yu keeps the overall experience quite intuitive. "I like to play with interactivity as content," he says, "but I strive for a simple navigation. Not in the sense that it's a menu bar, but that it's simple in terms of figuring out."

But the most important thing for him is to keep it all light, and that's why on DHKY, there is no rush, no schedule, and no pressure. While he's working on it, Yu takes his pretty time. Sometimes he'll even go a year between issues, though that doesn't mean he's not working on the site.

The result is a quick-loading experience that avoids the monotony of a rigid interface. To understand its content, you have to be somewhat familiar with Chinese culture, but if you are, it can be a good bit of fun.

"It started out without a plan," he says, "and it wasn't my way of telling the world how I feel. But the more I worked through it, the more interesting it became. It's been a real coming to terms with things."

/FUTURE

Given that Asian culture has been present in North America since colonial times, and that Americans still think fortune cookies are Chinese, it's easy to see that Yu won't run out of subject matter soon.

But his recent projects have shown a greater interest in collaboration over personal expression, so it's likely that DHKY will become more of a hub for such projects. In any case, it's been a fun place to visit for quite a while and that shouldn't change.

The central icon from *The Man with the Golden Arm* dominates the main page of the site. The layout is unusual, consisting of Bass-influenced off-kilter boxes and transitional elements that draw heavily on the designer's style. For example, the informational arrow at top slides onto the screen whenever the user mouses over a section.

/BOTTOM

For the display of Saul Bass work, Dawes used an interface based on the famous "dead guy" cutout from *Anatomy of a Murder*. Each section of the body links to a different area of Bass' activity.

/BACKGROUND

Brendan Dawes hails from Southport, England, and is admittedly an unlikely champion of Bass. An ex-photographer and DJ, his artistic career came to a halt around 1988, seven years before the advent of the Web. At that point, he needed money and took a job in an electronics factory drilling holes in fiberglass plates.

During that time, Dawes had always had an interest in computer-generated graphics and didn't give up on it. He learned to program the Amiga computer and picked up Photoshop from its 2.0 version. By the time the Web was in its Mosaic stage, he was already writing code for it. And when the Net began to take off, he knew he could have a career in it, if only he could grab the attention of the right people. So he built a personal site about *The Outer Limits*, a campy British television show and almost immediately landed a junior designer's position at Lancashire's Subnet New Media.

Subnet was a studio distinguished by both the high quality of its work and the perfect lack of design degrees among its staff. With his credentials, Dawes fit right in, but he also decided to learn a little more about the field he was working in. He ran into the work of American designer Saul Bass while poking through bookstores, but when he tried to find out more, he learned a nasty little fact. Though Bass had done much famous work, there were no books about him and no serious collections of his work.

That prodded Dawes into action. He gathered together what he could, and soon launched a small Web site devoted to the designer. Then a nice thing happened; Bass admirers around the world logged on and got into contact with him. Many had small collections of their own, and they all contributed what they could, with much of it coming from a Toronto-based designer named Victor Helwani. In no time, Dawes had an extensive collection of articles, main titles, film posters, and logo designs.

Since then, Dawes has devoted much time to updating the site and adding new features. These days, he's creative director at a company in Manchester, and though he's still far from his goal of having all of Bass' work available online, with each redesign he comes a bit closer.

/INTRODUCTION

If you ever want to uncork a really juicy rant, ask the local AIGA president what's wrong with the current crop of Web designers. Among the rash of topics sure to be covered is the fact that they have no sense of history.

This is largely a justifiable criticism. Some Web designers do adhere to the grid-based system of Josef Müller-Brockmann, but most either don't care about the past, or didn't pay attention in history class, if they went at all. Their strength lies in their ability to live at the edge of their field, and that takes all of their time.

Perhaps that's why it's fitting that the Net's only classic design tribute site was built by someone who sits squarely with the new generation—an ex-factory worker named Brendan Dawes who's never been near a design school except by coincidence. And it's even more fitting that Saulbass.net is a model of how to handle the genre.

1990'S

1980'S

1970'S

1960'S

1950'S

Grand Prix

Not with My Wife, You Don't

Seconds

Bunny Lake Is Missing

In Harm's Way

Victors, The

Nine Hours to Rama

Cardinal, The

It's a Mad Mad Mad Mad World

Advise and Consent

Walk on the Wild Side

Flashing Spikes

Something Wild

West Side Story

Psycho

Exodus

Facts of Life, The

Ocean's Eleven

Spartacus

/CONTENT

If you ever want to make the most obvious mistake in building a tribute site, all you have to do is to insert yourself into it. You want to give your fellow fans everything you can about their hero and leave yourself (in whom they have no interest) out. However, Dawes manages to break this rule and still succeed, mainly because he adds something that Bass himself thoroughly lacked— a light-hearted and self-effacing touch.

For those who are unfamiliar with him, Bass is one of twentieth century's most accomplished designers. Active from the fifties into the nineties, his main achievement is the introduction of Modernist principles into film posters and film title sequences. Before Bass came along, movie posters were simply pictures of the actors' faces along with heroic text, and titles much the same. Bass' idea was to reduce the whole theme of a movie to a single image and use that for both. In his first such project for Otto Preminger's *The Man with the Golden Arm*, for example, he avoided a smiling picture of its star Frank Sinatra, who played a drug addict. Instead, he wrapped the film's credits around the image of an abstract, tortured arm. The title sequence slipped the names of the characters alongside jabbing white bars, and finally resolved themselves into the same armlike image. Film design was never the same again.

From there, Bass went on to a long and busy career, and one which Saulbass.net traces both visually and historically. The site has the titles to films by Hitchcock, Preminger, and Scorcese. It has the many logos Bass produced in the late sixties and seventies, when film studios stopped funding main titles. It also has a biographical sketch, a filmography, as well as links to other Bass resources on the Net, including obscure branding documents from companies like AT & T.

Putting it all together is no easy task, and though fans would probably be perfectly happy with a massive archive, Dawes manages to do it with admirable tongue-in-cheek humor. He gives the name Saul Searching to his collection of links to Bass resources on the Net. Under Saul Food, you can see some of the designer's influence on present day design, including the highly derivative artwork done for the movie *Clockers*.

However, the most developed part of the site is the award-winning Psychostudio. In this section, Dawes takes a dig at the most controversial episode of Bass' career. Bass had served as an art director on the film *Psycho* and created the storyboards for its famous shower scene. But when the film came out, and the scene became celebrated, Bass claimed that he and not Hitchcock had directed it. Most critics have rubbished his claim (Bass was not a particularly humble man and his own films show no trace of the scene's genius), but Dawes decided to have a bit of fun with it.

For the studio, he separated out all of the clips of the scene, and then built a miniapplication that allows you to combine them any way you wish. Using a drag-and-drop interface, Psychostudio allows any arrangement of the scene. When you're satisfied with your own editing of the scene, you can publish it online.

It's this kind of tongue-in-cheek content that lifts the site above the ordinary and makes it worth a stop on the personal site tour.

At every turn, Dawes uses Bass-inspired typography and iconography. In this section dedicated to Bass' print work, the arms from Bass' famous "dead guy" cutout usher examples of his work on and off the screen.

Both the layout and the movement of the main title sequence for *North by Northwest* inspired the interface for the Bass filmography. As the user mouses over the years on the left, the interface slides its information into place using the elevator-like movement Bass had years earlier.

/TECHNIQUE

One of the few disappointments in the site is its Saul Food section, the part that traces Bass' influence on the rest of the world. The problem is that it has one glaring omission—the site itself. Nowhere else on the Web has the efficacy of the style of Bass' design been demonstrated so thoroughly.

Though it doesn't appear anywhere in the site, one of Dawes' main purposes in maintaining the project is to make a statement about Bass and the Web. It turns out that the first time Dawes really looked at Bass' main titles, he noticed something that seems quite obvious once he mentions it—they look exactly like they were done using Flash technology. In fact, the Modernist aesthetic did very much favor the kind of spare, two-dimensional graphics that can be easily converted into that format.

To make his point more emphatically, Dawes decided to build most of the site using actual Bass iconography translated into the format. The main interface, for example, uses iconography taken from *The Man with the Golden Arm*. And a slightly modified version of the poster for *Anatomy of a Murder* serves as the main navigation for the Bass portfolio section. In fact, Bass-style design, including nary a straight line, can be found everywhere in the site.

Much of the iconography did have to be adapted, however, and in doing this, Dawes played to his strength. If Bass was a master of motion graphics, Dawes designs some of the best transitions on the Net, and he found them the best place to incorporate his hero's style into the site. In the section for Bass' print work, for example, hands from the *Anatomy of a Murder* poster slide the posters and logos into place. Rollovers bring out information on wide, Bass-like arrows. Particularly effective is the list of film credits. They feature text keyed by an interface based on the title sequence to Hitchcock's *North by Northwest*. When any year is activated, its text slides elevatorlike into place, mimicking the frenetic pace of the original.

For the most part, the technology used in the site is simple, especially since a lot of its structure was in place long before the current version of the site received its face. Even so, Dawes is a noted coder, and in certain places, Psychostudio, for example, he isn't afraid to flex his coding muscles. But fundamentally, Saulbass.net is not a place he uses to show off his skills: Like most good sites, it uses exactly the amount of technology it needs to say what it wants to say.

/FUTURE

To this day, the site still remains the only robust resource for Saul Bass on the Net. It has even begun to exert a bit of influence of its own, thanks largely to the fact that it has catapulted Dawes to the kind of fame that successful Web designers get.

The future will probably bring an ever-growing number of updates— more movies, more stills, and more stuff. And for that, Dawes plans on relying on exactly what he already has—the community he's built for himself around the topic.

COLLABORATION

TEN YEARS AGO, NO AVERAGE JOE IN SOUTH AFRICA COULD HAVE DREAMED OF COLLABORATING WITH SOMEONE IN TOKYO. BUT IF THE WEB HAS DONE NOTHING ELSE, IT'S MADE THIS KIND OF EXPERIENCE COMMON.

EVEN SO, COLLABORATIONS ARE STILL AMONG THE MOST FAILURE-PRONE OF ALL ARTISTIC ENDEAVORS. IF YOU PUT TWO CREATIVE HEADS TOGETHER, YOU OFTEN DO LITTLE MORE THAN WASTE BOTH OF THEM AT THE SAME TIME. FOR A COLLABORATIVE SITE TO SUCCEED, IT HAS TO INSPIRE INDIVIDUAL ARTISTS, WHILE MAKING SURE THEY STAY FOCUSED ON THE GOAL AT HAND.

NATURALLY, SUCCESS IN THE FIELD COMES IN WIDELY DIFFERENT FORMS. A SITE LIKE BORN MAGAZINE, WHICH TEAMS DESIGNERS UP WITH POETS, PUTS INDIVIDUALS FRONT AND CENTER. THE ARCHITECTURE-CENTERED ARCHINECT, BY CONTRAST, RELIES ON A STRIPPED-DOWN MECHANISM THAT LETS ALL KINDS OF PEOPLE TAKE PART, NO MATTER HOW MUCH THEY KNOW ABOUT THE WEB.

BUT COLLABORATION IS NOT JUST A MATTER OF BRINGING OTHER ARTS ONTO THE NET. SOME, LIKE THE AUSTRALIAN INFRONT, MAKE SURE THAT WEB DESIGNERS WORK WITH WEB DESIGNERS AND THAT EVERYONE SHARES EQUALLY IN THE PRAISE AND BLAME FOR THE PROJECT. SIMILARLY, COMMUNICULTURE SETS UP A SYSTEM IN WHICH A WHOLE COMMUNITY OF USERS CREATES A COLLECTIVE ARTWORK BY FOLLOWING THE RULES OF THE SITE.

TOGETHER THESE SITES FORM A DIVERSE BUT COHERENT GROUP, AND PRODUCE SOME OF THE MORE UNIQUE WORK ON THE NET—AND ANYWHERE ELSE FOR THAT MATTER.

/TOP

Here, you can see a collection of sorted users (these are fictiously sorted as fans of Johnny Cash). If you mouse over one, they fly out of the group and display their user information.

/BELOW

Unlike many avatar-based sites, this version of Communiculture retains control over the design of the site by not allowing users to customize their appearance except for their aura. Here a character uses a utility to build its own aura.

/OPPOSITE

This screen from Communiculture shows how everything in the community gets a visual representation. The square clumps on the "trees" represent the different "farms," or areas the members of community are allowed to cultivate.

/INTRODUCTION

At a restaurant in San Francisco's SOMA District, Amy Franceschini, Josh On, and the rest of the Future Farmers aren't fessing up. "So what do you guys do?" a waiter asks.

Franceschini smiles. "We make birds," she says, "big, plastic birds."

This may be true, but the birds are a side project. Another side project, one that pays slightly better, is their Web design company. And still another is their digital playground, Communiculture. You might say the Farmers live in a world full of side projects.

But Franceschini doesn't blab on about all this. Behind her, the sun has settled its nose on the windowsill, a salad is on its way, and plastic birds sound much better. It's a Future Farmers kind of afternoon, a good time to be whatever you like.

124 FUTURE FARMERS

HTTP://WWW.FUTUREFARMERS.COM
HTTP://WWW.COMMUNICULTURE.COM

/INTRODUCTION
/BACKGROUND
/CONTENT
/TECHNIQUE
/THE FUTURE

MANETAS

COMMUNICULTURE

/BACKGROUND

It seems strange that the Farmers have thrown up a wigwam at the Kilowatt, a near-toxic biker bar in San Francisco. But on the second floor, a sewing machine chews at the felt on a backpack. Tools rest on tables, bolts of cloth stand in corners, and half-finished art is waiting for treatment. Nowhere can a computer be found.

Welcome to the Farmers' Analog Studio. The Digital Studio lies ten blocks north, through a genteelly rundown section of taquerias, private groceries, and nightclubs. In that office, things are a little more normal, or at least a little more high tech. The furniture is mismatched, but the G4s aren't, and like all designers, the Farmers sit glued to their monitors.

For years, the Web community has not known what to make of Amy Franceschini and the Future Farmers. They may preside over their world in pigtails and thrift-store clothes, but they know how to compete. They speak roundly of the environment, but they let clients like George Lucas, Levis, and Dreamworks drop their pound of flesh at the door.

One thing is sure: Franceschini has been on the Net as long as anyone. She started in 1996 with an art and photography site called *Atlas* magazine. *Atlas* turned out to be the first well-known piece of client-free design on the Net, and it launched quite a career for Franceschini. Soon, she found herself working for Levis and Lucasfilm, and building plastic birds whenever she got the chance.

But for all the rags-to-riches story, Franceschini is no guardian of the new economy. As a child, she grew up on a real farm that raised wheat grass and herbal remedies, and her values come from a different era. Her friends are decent but poor artists, and she is one of the few in the business that has watched the dot.com crisis with glee. "It's nice to know my neighborhood is going back to seed," she says.

Not surprisingly, her Farmers don't merely put emphasis on their personal work; they base their business around it. They are not cheap to hire, and they make a nice profit designing sites for others. But they work just enough to keep the bills paid and the computers running in top form. Beyond that, almost all of their time goes into their own projects.

Together with partner On and longtime collaborators like Sasha Merg and musicians Air King, Franceschini continues to mix business and art, and keep her karma intact as well.

/ABOVE

In this shot, a new "farmer" in Communiculture goes about building a plot. Each farmer gets a certain number of resources, but to make your garden bloom, you have to share resources with your neighbors.

To see how it works, take a close look at one aspect of the project—the avatars you use to navigate Communiculture. Since Franceschini likes everything to be represented visually, they were a natural part of the site. But she disliked the idea of letting people create their own representations of themselves. "I didn't want people to just make themselves," she says, "brown hair, blue eyes, and all that." She doesn't say it, but by creating someone who looks like you, of course, you can avoid immersing yourself in the experience, which is the whole point of the site.

Instead, Franceschini gave everyone a little kerchiefed person with a ribbonlike aura that follows him or her around. You can differentiate yourself from others, but you have to do it through this aura, not by changing the color of your pants. The site contains a special aura-builder for just this purpose. And in one particularly endearing extension of the idea, the auras from a group of users can detach themselves from their avatars and float in a side box. This box is the group's "collective consciousness."

As you continue with Communiculture, you are given a plot of land and allowed to populate it with various kinds of ground and trees, and even stash useful "resources" there. If you need something, you can take your avatar and walk around the farmlets and find things. These could be pictures, MP3s, and the like. Or you could simply stop by for a visit.

It sounds quite harmless (and probably is), but Communiculture does lead it users down along certain paths of interaction, and, in a way, forces them to acknowledge certain "truths" about collaboration, sharing, resources, and the environment.

Not all the Farmers' work is this ambitious, but Communiculture points out the general direction of their thinking. Teach people to appreciate certain things, and you can, perhaps, help the world along the way.

/CONTENT

Looking at the Farmers' work, you immediately fall into a magic garden world. It's a place of fantasies. Dreamy music breezes through pictures of dolls turning somersaults. Storks fly by dropping messages and miniature school buses tool along. The colors are mute and soothing. Nothing jars, nothing flashes, nothing threatens, and nothing moves fast. Even if you don't believe in this kind of world, you're happy there are people who do.

Given that, it's almost a shame to point out that the Farmers are a political lot. Perhaps not the sort to man the barricades and hurl firebombs at the oppressor, but extreme in their own way. You can find their leanings most easily in their latest work. Communiculture.

On the surface, Communiculture would not disturb a fire-and-brimstone Republican. The site offers its visitors a innocent-looking community based on the idea of farming. Users get to develop their own plot of land and share ideas and resources along the way. They can construct groups based on common interests and search visually for people like them. But behind it all, the Farmers are trying to create what On calls a "designed experience." They want to guide people through modes of interaction that they hope will teach them their values.

/TOP

Here is a well-developed farm maintained by a conscientious user. If all goes well, and you play by the rules, you too can have a piece of land like this.

/BELOW

Here is a good look at the kinds of three-dimensional objects that populate the world of Communiculture. The strange blue streamer over the character's head is its aura, a feature every user can customize.

/ABOVE AND RIGHT

These images show the various homepages of the Future
Farmers site. The intricate design and small type seem to
create a boundless space for the characters to play in. Part
of the joy of the site comes from all the fun the little guys
seem to be having.

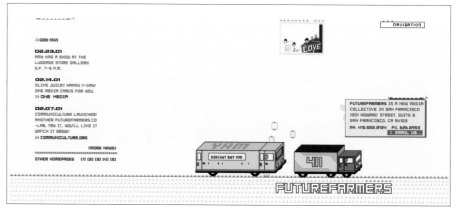

The nasty truth about good personal work is it doesn't take long to get something ninety-five percent right. The Net has no shortage of almost-good sites. But making a site really really good, and catching the roaming eye of the folks at Surfstation and K10K, is never easy. They know when you've cheated a bit, and they don't like it.

The Future Farmers have never had that problem, and with good reason. They work their little auras off. To understand their dedication, you can start with the two factors that jump out in any Future Farmers project. The first is the three-dimensional characters and their airy playgrounds of sounds, pastels, and friendly objects. The second is that their airy playgrounds often have more complex back-ends than Yahoo.

Franceschini is quite original in her use of real three-dimensional characters in her work. Many Web designers use three-dimensional objects, but they tend not to make them people, and they tend not to be really three-dimensional. The usual workaround is to photograph an object from several different angles, and animate it carefully.

Franceschini wants her characters to seem alive. They have to do more than twitch and rotate; they need to wave and jump. And to make this happen, she painstakingly models them in a three-dimensional program called InfiniD. She then animates them, renders the results out as movies, and brings them back, frame by frame, into her animation tools. To do a simple knee bend can take hours, but she doesn't consider her time wasted. Her little people are the only ones on the Web that can turn cartwheels, bounce off trampolines, and engage in sumo battles. And that's what she wants them to do.

The characters provide a microcosm of what the Future Farmers do with all of their work. From the beginning, Franceschini has collaborated with programmers on almost all of her projects, and has pushed the limits of programs like Shockwave. But these days, the availability of cheap back-end solutions has given the Farmers capabilities they've wanted for a long time.

In Communiculture, for example, On's programming is what allows the character "farmers" who come to Communiculture to interact so completely with the world. It tracks their motions through the site. It lets them collect and share resources and store their auras. It allows the auras to flit away from their avatars and join in the collective consciousness boxes.

Everything is entered into a dynamic database that updates the "farms" for each user. The end result is an experience that lets the visitors do a lot of the things the farmers care about: sharing, conserving, and thinking about what it means to live with others in this world.

/BELOW
..

This image comes from a seven-monitor installation Francescini designed for the Yerba Buena Art Center. The little robots read news from sites around the world.

/THE FUTURE

Sitting in the restaurant that day, the Farmers finally relented and admitted to being "dot.commers." But they should have added that they were around before people started selling pet food and bottled water online, and they'll probably be there long after too.

The Farmers are not much like anyone else, and will probably continue on in their own way for a long time into the future. Where exactly they will take their style and their ideas is a question no one can answer. But wherever it is, they'll probably keep making Web sites and plastic birds. And other things, too.

/ABOVE, TOP AND OPPOSITE

Some Advice in a Time of Excess, by Terry Kirts, with design by Fluffco. This post-modern rant found an able companion in the retro design of Fluffco. The piece shows, as much as anything else, Kean's skill in bringing the right people together for the right projects.

/ABOVE, BELOW

Some Guerrilla Physicists, by Michael Cowger, design by Ikda. A mingling of organic photos with technological grids and typography went well with a poem that also used imagery to bridge the scientific and human elements of experience.

/INTRODUCTION

Like most things under the sun, the mingling of design and poetry is nothing new. Ancient Greek potters put erotic verses in the bottoms of their drinking bowls, thinking that when the wine was drained, their readers would be in a better mood to appreciate them. William Blake designed elaborate borders around his poems, and Walt Whitman often shortened his so they'd fit nicely on the page.

Even so, the Web and its designers didn't immediately inspire poets, at least not good poets. Modern writers rarely publish their work for free. They're not fond of technology, and they don't like their words to be torn apart and scattered around. And not surprisingly, it took them a long time to catch on to *Born* magazine.

a nice little girl lived in a country village

/ABOVE
..

"Little Red Riding Hood," with design by Man Chiu Kwong.
Part of the ongoing experimentation at *Born* also involves
interpretation of classic stories. This tale got a macabre twist
in this beautifully illustrated piece.

/BACKGROUND

By Web standards, *Born*'s 1997 birthday makes it a dinosaur,
but unlike most dinosaurs, it's evolved up until the present day.
It's gone through more than twenty staff members with only one,
designer Gabe Kean, sticking around the whole time.

Kean launched *Born* when he was just out of college. At the time,
he wanted to pump up his portfolio, and an online magazine
seemed a good way to do it. Such projects are easy to launch,
cheap to produce, and can reach a limitless audience. But unlike
many early Web magazines, *Born* didn't talk about art or the
"scene." Instead, it took work from contemporary writers and
turned it over to designers for interpretation.

From the beginning, Kean has looked after the visual side of *Born*
and made sure it was among the best on the Net. Well-known Web
designers like Hillman Curtis, Joshua Davis, and Auriea Harvey
have all taken turns with it. Unfortunately, the site's writing side
hasn't been so lucky. During its early years, *Born* had a lot of dif-
ferent editors, and their contributions were mixed. Good writing
occasionally made it in, but more often it didn't, and sometimes the
literary product could be downright scary.

That changed when Kean took a job at Second Story, a Portland
firm that specializes in interactive narrative. There, he met co-
worker and longtime literary activist, Annmarie Trimble. Trimble
knew that, like Web design, literature has a lively underground with
its own heroes, cult figures, and publishing networks. But as far as
the general public is concerned, that scene is invisible, something
she has spent much of her life trying to change. She's run a writ-
ing workshop and belonged to a group called the Irradiated Poets,
who dress up in orange suits and read poems at malls and bus stops.

Trimble decided to give *Born* a try, and fell in love with the experi-
ence. "It's great to have someone interpret your work," she said.
"It's like looking into a reader's head." Shortly afterward, she
became the site's editor and has since managed to get a lot of other
writers involved. *Born* now attracts top literary talent, including
National Book Award nominees and other people who normally get
paid for their work.

With the two halves now on the same level, the site is booming in
popularity, and Kean and Trimble are dreaming up new ways for
writers and artists to collaborate.

Usually, collaborative art sites have a merry start. A designer goes out and invites some friends to contribute work. A couple of great issues come out, traffic numbers go up, and then things start to fade. The content becomes repetitive, the designer has trouble getting people to come on board, the visitors lose interest, and the whole thing dies an ugly, if richly deserved, death.

To survive as long as it has, *Born* had to have a durable concept. In its usual form, Trimble solicits work from writers of all kinds and turns it over to Kean, who parcels it out to designers. The designers, in turn, have a free hand in the interpretation of the writing. They can use whatever technologies they like and as much time and bandwidth as they need.

Such a format gives the site both flexibility and structure. The different writers provide a varied and ready supply of raw material. The designers, who come from all over the world, bring their own styles and outlooks, as well as their ability to interpret or misinterpret literature, as the case may be. The resulting product is understandably varied. Some designers handle each word like a Fabergé egg; others scatter them like farmers sowing wheat. Some make interpretive movies; others use no motion at all.

But the real backbone of *Born* is neither poetry nor design. It's a question: What does it mean to design literature on the Web? Every *Born* project, whether it has type dancing the Charleston or glowing like a medieval manuscript, has to have an opinion on the issue. And those answers, as different as they are, form a coherent body of work.

Over the last few years, the *Born* question and its answers have turned into a kind of running dialogue. The designers are well aware of what has been done before on the magazine. They know what's worked, what hasn't, and what hasn't even been tried. Every time they build a project, they are influenced by *Born*'s minitradition, and influence it in turn. If something goes well, future designers use it for inspiration. If a solution falls flat, it becomes a warning to others. In other words, *Born* has developed its own little genre and is still the only place in the world you can find it.

Currently, Kean and Trimble are exploring new ways to expand the concept. One new development is called the Birthing Room. It brings designers and writers together at an early stage and keeps them that way until their project is finished. Another budding project substitutes classical stories for contemporary writing. "The goal is really to create new kinds of experiences," says Kean.

Strangely enough, these advancing concerns have been accompanied by an increasing conservatism in the magazine's format. In the beginning, the site was published every other month, and the design was decidedly not printlike. Nowadays, it comes out on a quarterly schedule and looks like a poetry journal. Writers are listed first, and the design is restrained, with lots of white space and illustrations.

But however it looks, the magazine remains unique. "The reason I got into *Born*," says Kean, "is that the concept had legs." Five years later, those legs still seem ready to go.

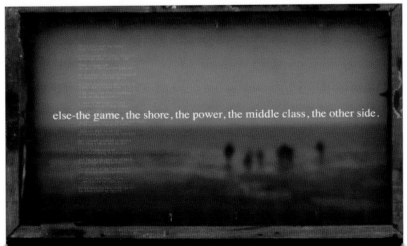

/LEFT, NEAR AND BELOW

His Father in the Exhaust of Engines, by Bruce Smith, with design by Mark Stricklin. A National Book Award nominee, poet Bruce Smith received a classic *Born* treatment with type fading in and out, and cinematic pans across pictures of middle America.

Year	Project Title	Author	Artist	Genre	
2001	Better Days	n/a	Skizz	Birthing Rm.	▲ Records:
2001	Born Magazine: The Video	n/a	n/a	Video	1 - 3
2001	Circus Premier	n/a	Richard, David	Birthing Rm.	▼ of 198

Just born:

Solstice
MARIA HUMMEL / JAMAL N. QUTUB

The Student Asks The Poet Basho: What Is Victoria's Secret?
TENAYA DARLINGTON / NINA DAVID

Honeymooning
MONICA DRAKE / MATT FONTAINE / THOMAS MASTORAKOS

Saving The Piano
DANNA SCHAEFFER / NANDO COSTA / CARLOS BELA

How To Survive Night Class
JENNIFER KOCHER / WARD ANDREWS

Waker
SUSAN MAXWELL / MICHAEL CINA

Announcements:

FLASH FORWARD: Two features from Born's Winter issue were finalists at the Flash Film Festival. "Walking Together What Remains" won top honors in the typography category.

BORN AT AWP: Editor Anmarie Trimble speaks on poetry and technology at the Associated Writing Program's Web Fair, April 18-21 in Palm Springs.

GRATITUDE: $ Jennifer Grotz, and Seb Chevrel.

NEXT RELEASE: July 1

BORN is a venue for design and literature collaboration. We exist to nurture the creative process and imagine unique forms of expression on the Web. Conceived from language and image, we intertwine concepts that have until recently been kept apart. The lines between reader and artist, sound and word, motion and image are ours to play with.

The Lines of the Hand
Seb Chevrel / Anya Medvedeva

COLLABORATE
WITH BORN MAGAZINE

*born*magazine DESIGN, LITERATURE, TOGETHER.

sponsored by
SECOND STORY

"Born Magazine: The Video"

/ABOVE
..

Born's interface is one of the classics in client-free design, especially because of the intuitive search engine at the top bar of the page. To the left are the links to current projects; in the middle the current news; and in the bottom right, the Birthing Room.

/TECHNIQUE

The main problem with maintaining a collaborative site like *Born* is that it bogs you down with production work. Every new version of the site adds anywhere from eight to ten projects, all of which need custom-sized windows, written introductions, and space on the server. During *Born*'s early years, all this had to be done by hand, and with Kean working a full-time job, there wasn't much time to do anything else.

Last year brought changes. "It's not the exciting part that anyone wants to hear about," says Kean, "but it has really helped us work on new things."

During its redesign, the site acquired a sleek XML backbone programmed by Kim Markegard and Daryn Nakhuda. It's a complete publishing system custom-made for *Born* content. It calls the individual files, throws them up in the appropriate window sizes, and automatically generates the file structure. Merely by typing a few lines of code, Kean can add projects to the archive, place them on the front page, and generate a table of contents. In fact, if he has all the files he needs, he can do an entire quarterly update in an hour or so.

On the front end, the site is similarly well designed. It provides two different ways to access its content, the first naturally being the fea-

tured links to new projects. But the second is what some regard as the best search function on the Net. It resides in the top bar of the site and has entry fields for authors, designers, titles, and genres. If you begin to type in any of the fields, the engine automatically sorts the content by that category and scrolls down to the closest item to your search.

Even the pieces that lie outside the normal structure of the site are easy to access and modify. The Birthing Room, for example, is supposed to produce projects organically, so it doesn't run on a rigid update schedule like the rest of the site. But its dots-in-a-box interface, which was designed by Second Story's Seb Chevrel, requires only a few lines of code to add or subtract a project.

Kean and Trimbe make sure the human element of *Born* is similarly well organized. The site has no editorial meetings, or meetings of any kind. Its ten or so staff members communicate entirely by e-mail or in one-on-one meetings. Trimble handles the literary side; Kean looks after the design; and everyone else comes in on an ad hoc basis. Streamlined and pleasant is the order of the day.

For those looking for the proper moral to pull out of *Born*, it's pretty clear. If you're going to do this kind of thing, figure out a way that's not going to kill you. Otherwise, it'll never last.

Spring 2001

ENTER BORN MAGAZINE

Art Director: Gabe Kean
Editor: Anmarie Trimble
Contributing Editor: Jennifer Grotz
Technology Team: Kim Markegard,
Daryn Nakhuda, Seb Chevrel
Video Editor: Craig Ernst
Video Designer: Kevyn Smith

Contributing Writers
-**Monica Drake:** Portland, Oregon
-**Susan Maxwell:** Iowa City, Iowa
-**Maria Hummel:** Hollywood, CA
-**Jennifer Kocher:** Portland, Oregon
-**Tenaya Darlington:** Madison,
Wisconsin
-**Danna Shaeffer:** Portland, Oregon

Contributing Artists
-**Nina David** Duesseldorf, Germany
-**Anya Medvedeva (alterpath)**
Portland, Oregon
-**Seb Chevrel (sebchevrel.com)**
Portland, Oregon
-**Michael Cina (mikecina.com,
trueistrue.com)** Minneapolis,
Minnesota
-**Chiu Kwong Man
(sexliesandfairytales.net)** London,
England
-**Jamal N. Qutub (Nimpsy)**
Portland, Oregon
-**Chris Brown (rhythmrevolution)**
New York, New York
-**Nando Costa (HungryForDesign)**
New York, New York
-**Carlos Bela (Golden Shower)** Sao
Paulo, Brazil
-**Motomichi Nakamura (Juvenile
Media)** New York, New York
-**Matt Fontaine / Thomas
Mastorakos (OneTenDesign)** Los
Angeles, California
-**Ward Andrews (drawbackwards)**
Tempe, Arizona
-**David Richard (popsicleriot)** San
Francisco, California
-**Simon Redekop (HUMAN 05)**
Vancouver, British Columbia

cover by Simon Redekop

*born***magazine** DESIGN, LITERATURE, TOGETHER.

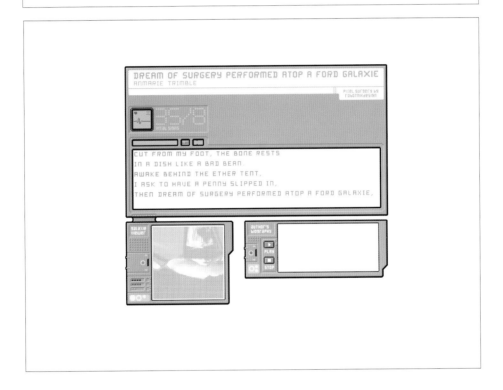

/THE FUTURE

As *Born* turns five and hustles into kindergarten, you might think its proprietors are a bit sick of it. Hardly any magazine seems to last on the Web, especially ones that are produced on enthusiasm alone. But the site shows few signs of let up. "I think it's just getting going," says Kean.

When asked why he devotes all his free time to something that chews up most of his free time, Kean shrugs. "It feels like a moral project," he says. "When I got out of school, everything else felt like selling out. With this, I feel like I'm doing something."

/ABOVE

The landing page of *Born* features the clean layout and white space of a literary journal. Part of the purpose of the design is to assure visitors that *Born* is a literary magazine first and a design project second.

/BELOW

Dream of Surgery Performed Atop a Ford Galaxie, by Anmarie Trimble, with design by Robotnik design. This well-titled poem laden with American references received a spacey interface and typography. Trimble liked the design enough to go on to become the editor of *Born*.

Urban/Type International was one of the more interesting projects put together by Karlsson. It invited designers to take pictures of different uses of type characteristic of the city they lived in. The participants came up with some excellent examples of typical signage in their towns, including New York taxis, London addresses, and an interesting sign that warned people in Cape Town that they were not allowed to bring their axes on the train!

/OPPOSITE

A bag of plastic parts for a glue-together model formed the basis of this design. Karlsson often favors such found objects in his work.

/INTRODUCTION

But for the Internet, Henrik Karlsson might still be sitting in a small Swedish town writing copy for the local newspapers and radio stations. It wouldn't be a bad life, but nothing like the globetrotting he's managed to squeeze into the last few years.

His travels have had a lasting effect on him, and one that often shows up in his personal work at Module 8. Though the site is primarily an experimental tool, its best moments come when it looks at how cities acquire the peculiar feeling they have, and how to express that visually.

/BACKGROUND

In some ways Henrik Karlsson's life has always been heavy on the vagabond. He's the sort of person who falls into things, and the first thing he fell into was a succession of journalistic jobs. In his hometown of Karlstad, he worked for radio stations and newspapers, reviewing films, music, and, oddly enough, Web sites.

But after a while, he realized he wasn't exactly where he wanted to be, and to sort it out he turned to one of the world's more unique colleges: the Hyperisland School of Design. Situated in an old naval prison in Karlskrona, it places its students in cells along with all the computers and software they want. Lectures are few and assignments minimal.

For truly motivated, the system works, and Karlsson was a model Hyperisland student. Already interested in the Web, he spent almost all of his time on the computer and soon became a competent programmer. Inspired by people like Matt Owens, he soon launched his own experimental site at Module 8.

Beyond his personal and professional work, Karlsson organized a conference in May 2000. Called Project 40, it brought together some of the world's top personal site designers for the first time and allowed him to make the connections he's used for his collaborative projects ever since.

Nowadays, Karlsson lives in New York and continues to work on Module 8 whenever he can find the time.

Module 1.1

Each plastic part is identified by a number.
Cada pieza de plástico se identifica por un número.
Elk plastic onderdeel is genummerd.
Jedes plasticteil ist durch eine nummer gekennzeichnet.
Alla plastdelar har identifikationsnummer.
Ogni pezzo è identificato da un numero.

Do not cement.
Niet lijmen.
Nicht Kleben.
Limmas inte.
Non incollare.

Alternative assembly.
Ensamble alternativo.
Andere wijze van sämmenstelling.
Eine andere möglichkeit.
Alternativ sammansättning.
Alternativa di montaggio.

Module 2.1

Repeat several times.
Arbeitsgang mehrmals wiederholen.
Repita varias veces.
Enige keren herhalen.
À répéter plusieurs fois.
Arbetsmoment som upprepas.
Ripeti diverse volte.

DER GRÜNE PUNKT

DER GRÜNE PUNKT

"LES SACS DE PLASTIQ
PEUVENT ETREDANGEREU
POUR EVITER LE DANGER
SUFFOCATION, NE LAISS
PAS CE SAC A LA PORT
DES BEBÉS NI DES ENFANTS

Though Karlsson once organized a whole conference dedicated to the lofty word "process," in truth, he has very little to say about the word in his own work. Module 8 just a big experiment, he admits.

"I didn't have a creative concept form the start," he admits, "I was just playing with code ideas, and I think a lot of people work like that. They find something cool in Flash or HTML and from that they get an idea."

But like many projects, Module 8 has grown into its theme more as it's gone along. With the advances in Web technology, and the slow extinction of the designer/programmer, Karlsson has found himself focusing more and more on purely visual projects. And not surprisingly for a person who grew up in a small town, one of his favorite topics has been cities.

Naturally, Karlsson involves friends around the world for these kinds of studies. In them, he tends to pick out a single aspect of an urban environment and try to pull in examples of it from around the world. One, for example, asked his friends to take photographs of interesting and characteristic uses of typography around their hometowns. His respondents sent in pictures of New York taxis, London addresses, and odd South African signs that warned passengers to please not take their AK-47s on board trains.

To do this kind of project requires not only planning, but also a careful selection of those involved. The more well-known designers are often less useful than the dedicated few who like to think things through. And in fact, the people Karlsson chooses are often much like himself—hale-fellows-well-met, without much in the way of egos. In dealing with them, he tends to undersell the project, and not try to make it sound either epic or dull. But, on the other hand, his concepts tend to be interesting and unique enough that he has little trouble getting his companions to play along.

In executing the projects, Karlsson is similarly low key. His designs tend merely to be clean, personality-free interfaces that put the emphasis on work of his fellow collaborators rather than on his own work (he never contributes to the projects). They usually don't ask a lot of the contributing designers; a few photos and some text are all that's required; something that's not the least bit useful in getting other people to work with you for free.

In other words, Karlsson tends to choose projects that require a good deal of collaboration, but he tries to make the subjects as attractive and the process as painless as possible. It's a formula that works well.

/BELOW

In all his projects, and especially in collaborative ones, Karlsson tends to prefer minimalist interfaces that don't draw attention to themselves.

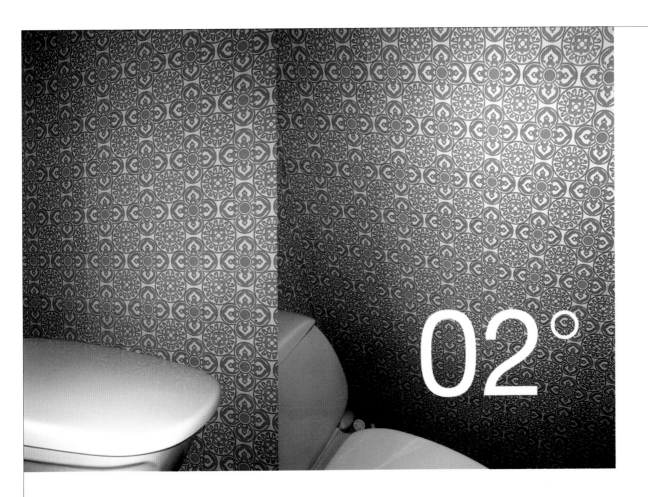

www.module8.com

/ABOVE
...

The odd wallpaper in a bathroom formed this design for
Matt Owens' Codex project.

/THE FUTURE

Unlike many personal site designers, Karlsson has a very full pro-
fessional career that leaves him little time for the kinds of projects
he likes to do. But with luck, the future holds more urban studies for
Karlsson, and more work on Module 8.

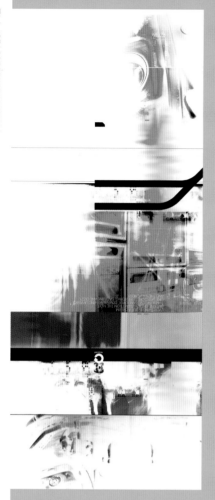

/THIS SPREAD

This quick visual dialogue was actually done specially for this book. The unique size and sectioned appearance of Dominic Bartolo's original image held up well with the other designers Justin Fox, Ryan Hays, and Matthew Willis. Willis' final image draws together the mirrored suggestions found in the other pieces, and the others obviously liked it enough to cut the dialogue short.

/INTRODUCTION

Ask any Australian how the world sees Aussies in general, and you'll probably hear they're underrated. Ask about any specific Australian, and you'll probably hear they're overrated, if you don't hear worse. Down under, they call this the tall poppy syndrome, the tendency to cut down those who rise above the rest, while somehow feeling that Australians don't get the respect they deserve.

Needless to say, this makes life rough for Australian Web designers. The Web likes tall poppies and grows them by the hundreds in its tiny world. But such fame has little attraction for the designers at the Australian InFront: They want respect, not stardom, and they are willing to invent their own forms of artwork to get it.

form is emptiness, and the very emptiness is form;
emptiness does not differ from form, form does not
differ from emptiness; whatever is form, that is
emptiness, whatever is emptiness, that is form.
- heart sutra

emptiness, and
does not di
n emptiness; w
mptiness, whatever is
heart sutra

form is emptiness, and the very emptiness is form;
emptiness does not differ from form, form does not
differ from emptiness; whatever is form, that is
emptiness, whatever is emptiness, that is form.

/THIS SPREAD

This Visual Dialogue features the work of Domenic Bartolo and Justin Fox. Bartolo began with a heavily layered, typographic design. Fox picked out several shattered and circular aspects of it, and introduced a new color scheme. The two batted these ideas back and forth until Fox's final, fractured circle of a design.

/BACKGROUND

The Australian InFront began at a meeting on a beach, and that tells you something about the country's Web scene in 1997. Back then, it was so busy that anyone who went to the beach had to bring a meeting with them.

Among the hardest hit were a tattooed exgrunge rocker named Justin Fox and his partner Caryn Gillespie. They had two big problems. First, they were buried in work and having a hard time finding talented freelancers to help them do it all. At the same time, they had found out about the Web scene and its bloated list of stars and were not thrilled that they all came from Europe and the States. They knew plenty of Australians and others who were on a par with the rest and, frankly, they wanted to make sure everyone got the notice they deserved.

Then Fox got an e-mail from Andrew Johnstone, a fellow Aussie who was looking for help starting up an interview-and-news site called Design is Kinky. Fox liked the idea but was more interested in collaborating on something else. He wanted to build a site that would not only bring him into contact with other Australian designers but also present the Australian Web to the world.

A handful of people showed up to their beach meeting. It was a beautiful day. The sand was warm, the water sparkled and the pale, sun-deprived skin of the designers probably roasted like crabs in a pot. But in the end, Australia's two best-known underground sites managed to go forward: Design is Kinky, and the InFront (for more on Design is Kinky, please see the Portal section on page 155).

The InFront's name comes from the opposite of "outback," and its first order of business was to set up a place for designers to meet and share work online. But it also started to bring them together for special artistic projects.

Today, the organization includes nearly twenty designers, and has become a loud and vital voice not only in Australian design but everywhere else, too.

SAMPLE//0.1

MARINE_LIFE

/CONTENT

When you have twenty energetic people working on your Web site, it doesn't end up lean or waiflike. In fact, the InFront bulges with content: news, forums, links, and designer profiles. All of it is perfectly good, unobjectionable stuff, but where the site really sets itself apart in its two inspirational projects: the Visual Dialogue and the Visual Response.

The Response, which is the simpler of the two, is the brainchild of Sydney designer, Dominic Bartolo. It typically asks designers to interpret a single, suggestive word, like "culture." The catch is that the playing field for is kept very level: Your end product must be a single graphic that's the same size as everyone else's, and it can't contain any photos or scans. Everything in it must be created *de novo* in a program like Photoshop or Illustrator. "It avoids someone using an amazing photograph as a great start to an image," says Fox. "It's such a great challenge."

Slightly more involved is the Visual Dialogue, which is one of Fox's ideas. Though it has many different variants, the usual Dialogue begins with one designer creating an image and sending it to another. That person does an "interpretation" of the image and sends it back. The dialogue can continue for many turns and only ends when the two are satisfied with the result. In most cases, the artwork shows a huge drift over time: The original image disappears, and the designers come up with a final piece that's far removed from anything they started out with. "It is a conversation between two creatives," says Fox, "but instead of using words, you are using images, passing them along like Chinese whispers. It's a great way to get to know someone."

Beyond providing a way to make inspirational design work, both the Response and the Dialogue have a special allure for Australians, in that they avoid turning their participants into the tall poppies they dread. The Response, for example, is open to anyone, and all of the results, regardless of quality, are posted together. A piece of beveled junk could end up right beside the next Starry Night. Not to be outdone, the Dialogue also deflects the credit for the product of its labor. Instead of getting personal recognition, the participants push and pull, and the success of their efforts depends as much on how well they play off each other, as it does on their individual talents.

Of course, since the site has grown in popularity, and the typical Response now gets hundreds of submissions, InFront has started highlighting a few of the better ones. But even then, they normally spread the glory around ten different images, and make sure no one gets a big head about it.

In this way, the site manages to do pretty much what it intended: to let Australian designers take their place among the best of the Web, without laying claim to any individual merit. It's a successful coping mechanism for a culture that clashes with the usual underground ethos.

/TECHNIQUE

To work on projects like the InFront, you have to be something of a diplomat, and that is not a common quality among creative people. No matter how nominally collaborative most Web sites are, they usually have a point person, someone who can muzzle those who whine too much or criticize too colorfully. And though the InFront has a bit of that in Fox and the three other designers of the site (Bartolo, Ryan Hays, and Matthew Willis), for the most part it acts as a big, egalitarian group.

Since the members of the organization are scattered all over their huge country, they usually do their work by e-mail, and possess one of the best-mannered mailing lists around. More often than not, it resembles a room full of people trying graciously to get out of each other's way. When discussing one of the site's numerous redesigns or poster projects, they may say, "I think it totally stinks," but they usually preface it by saying something like, "I don't want to be the one to have to say this, but in my opinion, and this is only my opinion..."

Working on InFront creative projects requires similar self-control. The first impulse everyone has in doing something like a Visual Dialogue is to create things that are vaguely suggested by what your partner is turning up, but not related to them. To be successful, Fox advises concentrating hard on what the other person is doing. That way, the production pattern will show not a pair of people doing their own things, but two styles moving down parallel paths and hopefully meeting in the end. In one excellent example of the genre four different designers put a vertical, sectioned layout through several different variations until a final, reflected-building image by Matthew Willis provided a surprising and satisfying close.

Another advantage of keeping so many people on board is that a lot of ideas fly around, and some of them are quite good. For example, the InFront, leaning heavily on its back-end programmer David Johnson, has produced one of the more sophisticated featured artist sections online. Unlike most such profiles, which go out of date quickly, theirs allows the featured designer to update his or her own artwork. This makes it an up-to-date resource for outside companies looking for designers, and eliminates the main problem with design exhibits, namely, that they get out of date quite quickly.

In other words, the Australian InFront is a site whose main accomplishments are achieved by subsuming egos in favor of the group and working very closely together, not only in planning a site, but in turning out the creative projects as well.

/FUTURE

Recently, the InFront has seemed to become more comfortable with itself and with its role as a critical voice in the Web community. Whether that will continue or create a backlash remains to be seen.

In any case, it's one of the most actively redesigned of all portals, logging a look every few months, and continually adding and subtracting from its content. That makes it hard to say exactly what will happen with it in the next few years, though it's difficult to imagine Australian Web design without it.

/THIS SPREAD

A Visual Response on "marine" drew out these images from members of the team. The yellow liquid that spills across Ryan Hays image contrasts completely with the disintegrated underwater design of Caryn Gillespie.

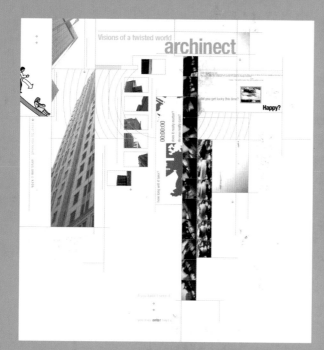

/ABOVE

This image is a rare cover from Mike Schmidt, who is better known for his work on the design portal Kaliber 10,000. It mingles photos of buildings with the kinds of creative questions that vex designers and architects alike.

/BELOW

Archinect's classically quick and easy interface is split neatly in half between the special projects index and the popular posting board. Well-designed and easy to use, it's exactly what any portal should be: simple.

/OPPOSITE

This cover, created by Chris Minnick, which seems to draw on heating ducts for its inspiration, is a good example of the quasi-architectural work that Web designers often contribute to the site.

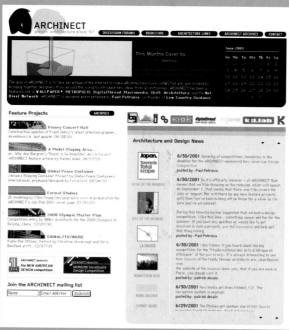

/INTRODUCTION

When fools rush in to the Web, they take one word with them: interactivity. But though interactivity may be what makes the Web different from other media, it's not ipso facto what makes it good. At their best, Web sites are well-crafted environments that lead people in, surround them with an experience, and let them do what they want.

Not surprisingly, the Web has proved a good alternative career for young architects, a group of people trained in creating spaces that are both interesting and functional. And no one knows this better than Paul Petrunia, the ex-architecture student turned Web designer who runs Archinect, an online meeting place for the two fields. The site's mix of news, opinions, and artwork has made it one of the more surprising stops on the Net.

Disney Concert Hall Construction Photo Documentary

architecture by Frank O. Gehry and Associates
photography by M. Scott Fajack
web design and maintenance by Jeff Faulkner of parisfranceinc
programming by Aaron Anderson of parisfranceinc
pimpin' by ARCHINECT

home

A STRATEGY FOR WORK

Working as both the designers and builders of the project reduced the traditional separation between conceptualization and materialization, challenging our abilities as both thinkers and makers. The work was thought of as a form of interference with the existing building – and light as the primary material. To a radio signal, interference is the enemy. As designers, we were much more interested in the potential interplay between what might be considered signal and noise.

SIGNAL/TO/NOISE FULL DOWNLOAD
14 pages / 35 photographs / 7 drawings /
5 renderings / 570 words / 2.2MB

Adobe Acrobat Reader required

M1

/BACKGROUND

Archinect calls itself a collaboration, and in one sense that's true:
It does have a whole parade of people involved. Every month, a
new Web designer creates a cover for the site and architects around
the world contribute photos. No less than twenty people post to its
news board, and hundreds more chat away in its forums. But make
no mistake: Archinect is really the personal project of Paul Petrunia.

Now in his late twenties, Petrunia hails from the green city of
Victoria, British Colombia. While growing up, he dreamed of being
an architect and never thought twice about design. But that all
changed at the University of Oregon, when he took a class on the
Internet and built a small Web site called Archinect. Its inaugural
issue was nothing more than a list of architecture resources, but it
was enough to bring him into contact with people around the
world. Every day, he got e-mail from someone he didn't know; and
every day he learned more about how architecture was adapting
itself to the Web. Needless to say, it got his imagination going.

Not long after, he headed south to the Southern California Institute
of Architecture, where he convinced his professors to let him
redesign the school's Web site. That led to a summer job working
for Los Angeles architect Eric Owen Moss, which in turn led to
another job working for another architect. Within a few months
Petrunia had quit school and was working full time as a freelance
Web designer.

Meanwhile, he was discovering the vibrant Web underground.
Especially impressed by its sophisticated portals, he became deter-
mined to turn Archinect into a similar resource, full of special art
projects and up-to-date news and gossip about the world of archi-
tecture. He added posting boards and began inviting the best
designers in the world to help out. And they did.

Nowadays, Petrunia spends almost all of his free time on the site,
and his biggest hope is to someday be able to make it his job.

/CONTENT

"Archinect is different from trade journals or architecture maga-
zines," says Petrunia, "because it's about creating an awareness."

The awareness he's trying to create is not geared towards Web
designers, even though they probably could use a bit more expo-
sure, especially to sunshine. But alas, the site is for architects, and
its purpose is to expose them to the avant-garde imagery of the Web.

To do this, Petrunia pulls a classic bait and switch: He provides a
service so useful that it's impossible for most architects to ignore,
and then surrounds it with excellent Web design. The service in
question is a news-posting board, something that's quite common
in the online community, but otherwise unheard of in the architec-
tural world. The way it operates is this: Petrunia chooses twenty
people who can post links to anything going on in the field: lec-
tures, books, museum exhibits, and even new Web sites. Their rec-
ommendations, which can contain links, appear in a window on
the front page of the site. And thanks to the high number of posters
and their excellent connections, Archinect can pick up on almost
every scrap of news and gossip in the field. And since architects are
human and as such can't resist the lure of juicy gossip, the site has
long since blown by the field's more respected journals in popularity.

With the hook firmly lodged in his prey, Petrunia proceeds to bring
in Web design, generally in two types of special projects. First and
foremost are covers for the site, which are mainly done by well-
known designers from the personal site world. They tend to be
graphically interesting, but rarely show much detailed knowledge
about architecture.

By contrast, the site also has its own minifeatures on architecture
projects, and these can be quite savvy. It has covered the con-
struction of some of the world's newest and most anticipated build-
ings, including ones by Eric Owen Moss and Frank Gehry. Such pre-
sentations normally take the form of a series of photos taken at reg-
ular intervals from a specific spot. By clicking through them, you
can get a good idea of how a certain space has been transformed
over time. In addition, the site features a great deal of theoretical
work, often from students, who can submit their drawings and
models, which generally find a sympathetic audience in Petrunia.

The final result is good for both fields. Web designers can gain
exposure to an ancient and honorable profession, while architects
can do the same with a new and not entirely reputable one.

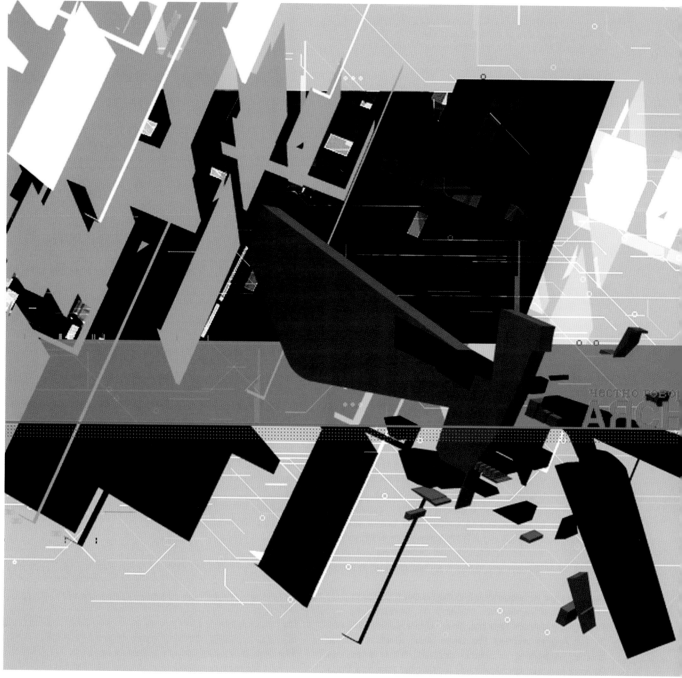

/ABOVE

Danish designer Anders Schroeder of Dform 1 created this blocky cover for the site, incorporating a popular three-dimensional style. Like many productions of Web designers for the site, it is only very tangentially about architecture.

/RIGHT

James Widegren, a Swedish designer who runs Web portal Threeoh, contributed this beautiful cover to the site. In it, Widegren is interpreting Archinect itself, and the fertile connections it tries to foster between its two audiences.

/TECHNIQUE

There is an old saying about experience, namely that it is what you get when you don't get what you want. And Archinect, like many things on the Web, got a lot of experience in its early years, much of it centered on the usual surfeit of technological experimentation. But like many sites, it was to learn that "completely revolutionary" and "completely worthless" are not mutually exclusive terms.

Early on, Petrunia encouraged designers of his special projects to push technology and not worry about usability, speed of production, and the overall experience of a people who returned to a site every day. For their covers, Web designers used all the latest and greatest plug-ins; and, in turn, the site's architecture projects would show off all the advantages of using interactivity to display buildings. In this era, Archinect had lots of wild fly-throughs of rooms with panoramic pans and scales, and click-through navigations that let you walk up stairs and open doors.

Of course, there was nothing wrong with all that as an experience. Interactive technology can do wonderful things for architecture. In fact, allowing for the limits of the screen, you can come very close to the real experience of being there, but, and this is an enormous but, building such experiences is incredibly labor-intensive, especially when you compare it with the minuscule amount of time it takes to actually view one of the projects. The real issue that Petrunia ran into was that since he wasn't paying for the work, the pieces rarely got finished. Over time, he found that it was more satisfying for a repeat visitor to see more projects done less elaborately.

So he has found himself resorting to an old idea—templates. Nowadays, he has standard layouts with specific spots for the photographs and texts. To put up a project, he simply asks contributors to send him the basic materials, specify background colors, and choose a template. Simplicity and volume reign over the entire production.

Similarly, Petrunia is looking for simpler ways to update his site and make it so that it runs with less effort. With inexpensive database technology he can now do updates more quickly, and leave himself more time to solicit work from architects and designers.

/FUTURE

It's not hard to understand that Petrunia gets his share of criticism from traditional architects. Without a degree and in a field many of them despise, he hasn't had it easy.

But it is as certain that Petrunia will continue on with Archinect, as it is doubtful that anyone will be able to match it or replace it. In fact, Petrunia is hoping sooner or later to cut a deal that will enable him to do it full-time. For now, though, that remains in the future.

PORTALS

IT MIGHT SEEM IMPOSSIBLE TO KEEP UP THE PERSONAL SITE WORLD. EVERY DAY, DOZENS OF SITES GET UPDATED, AND DOZENS MORE GET LAUNCHED FOR THE FIRST TIME, EACH ONE WITH HIGH AMBITIONS OF GETTING THOUSANDS OF VISITORS AND A SPOT AT THE PODIUM OF THE NEXT WEB DESIGN CONFERENCE.

TO KEEP YOUR FINGER ON THE PULSE OF THE MOVEMENT, THE BEST THING TO DO IS FIND YOURSELF A PORTAL. THESE SITES COME IN ALL SHAPES AND FLAVORS, BUT THEY ALL WORK IN MORE OR LESS THE SAME WAY. THEIR EDITORS SIFT THROUGH HUNDREDS OF E-MAILS A DAY FROM DESIGNERS AROUND THE WORLD, AND POST THE LINKS THEY LIKE TO A NEWS BOARD.

THE FOLLOWING IS A SAMPLING OF SOME OF TODAY'S MORE ACTIVE PORTALS. THOUGH THEY TEND TO POST MANY OF THE SAME LINKS, EACH HAS ITS OWN PERSONALITY AND TASTES, AND IT'S PROBABLY BEST TO SHOP AROUND A FEW BEFORE SETTLING ON THE ONE YOU LIKE.

By far the most popular of the design portals, K10K is a Danish original, put together by designers Mike Schmidt and Toke Nygaard, as well as programmer Per Jørgensen. It features twenty posters who provide twenty-four hour a day links to new sites and happenings in the Web design world. Sometimes resembling a circus more than a design-posting board, one of its best attractions is watching Schmidt play straight man to the richest cast of characters on the Net.

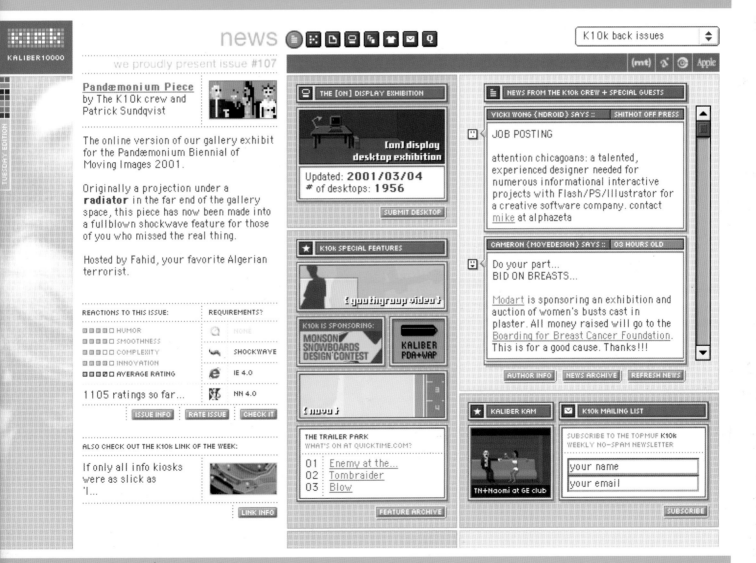

KALIBER10000

news

K10k back issues

(mt)

Apple

we proudly present issue #107

Pandæmonium Piece
by The K10k crew and
Patrick Sundqvist

The online version of our gallery exhibit for the Pandæmonium Biennial of Moving Images 2001.

Originally a projection under a **radiator** in the far end of the gallery space, this piece has now been made into a fullblown shockwave feature for those of you who missed the real thing.

Hosted by Fahid, your favorite Algerian terrorist.

REACTIONS TO THIS ISSUE:	REQUIREMENTS?
▧▧▧▢▢ HUMOR	NONE
▧▧▧▧▢ SMOOTHNESS	
▧▧▧▢▢ COMPLEXITY	SHOCKWAVE
▧▧▧▧▢ INNOVATION	IE 4.0
▧▧▧▧▢ AVERAGE RATING	
1105 ratings so far...	NN 4.0

ISSUE INFO RATE ISSUE CHECK IT

ALSO CHECK OUT THE K10k LINK OF THE WEEK:

If only all info kiosks were as slick as 'I...

LINK INFO

THE [ON] DISPLAY EXHIBITION

[on] display
desktop exhibition

Updated: **2001/03/04**
of desktops: **1956**

SUBMIT DESKTOP

★ K10k SPECIAL FEATURES

{ youthgroup video }

K10k IS SPONSORING:
MONSON SNOWBOARDS DESIGN CONTEST

KALIBER PDA+WAP

{ nova }

THE TRAILER PARK
WHAT'S ON AT QUICKTIME.COM?

01 Enemy at the...
02 Tombraider
03 Blow

FEATURE ARCHIVE

NEWS FROM THE K10k CREW + SPECIAL GUESTS

VICKI WONG {NDROID} SAYS :: SHITHOT OFF PRESS

JOB POSTING

attention chicagoans: a talented, experienced designer needed for numerous informational interactive projects with Flash/PS/Illustrator for a creative software company. contact mike at alphazeta

CAMERON {MOVEDESIGN} SAYS :: 03 HOURS OLD

Do your part...
BID ON BREASTS...

Modart is sponsoring an exhibition and auction of women's busts cast in plaster. All money raised will go to the Boarding for Breast Cancer Foundation. This is for a good cause. Thanks!!!

AUTHOR INFO NEWS ARCHIVE REFRESH NEWS

★ KALIBER KAM

TN+Naomi at GE club

✉ K10k MAILING LIST

SUBSCRIBE TO THE TOPMUF K10k WEEKLY NO-SPAM NEWSLETTER

your name

your email

SUBSCRIBE

LINKDUP
HTTP://WWW.LINKDUP.COM

/BACKGROUND

London-based design firm Preloaded owns this review and posting board. The site keeps an archive of mini-screen shots of more than 2,500 sites and also has a ranking and reviewing system, making it the largest attempt on the Net to catalog and keep track of the evolving state of design. Useful to designers and marketers alike, it has a sophisticated back end that lets you keep a personal library of your favorite sites.

/BACKGROUND

Probably no site on the Net offers more design links per day than Surfstation, the pride of the Luxembourg Web. With posters from Colombia to Russia, the site's range is global, though it is naturally strong in content from Western Europe. What's more, links are just one small part of the massive amount of content found on this site, including music reviews, desktops, and downloadable Photoshop actions. Surfstation is a monster, and definitely in a good way.

SURFSTATION
HTTP://WWW.SURFSTATION.LU

THREEOH
HTTP://WWW.THREEOH.COM

Maintained by the Swedish design prodigy and fashion model James Widegren, Threeoh is something more than a Web log, something less than a magazine, but a good place to get a no-nonsense list of links. Widegren favors the clean and minimal, and if he posts less, it's because he is a lot less forgiving than other portal editors. The site also features an occasional article or interview and has a good handle on what's new in London, New York, and Washington, D.C.

If you're interested in the scene in Australia, look no farther than Design is Kinky. Sharing many staff members with the Australian InFront (profiled on pages 144-145), DIK does more than most to track down the personal site designers that everyone wants to hear from, and ask them the questions everyone wants answered. Aside from its interviews, it also has plenty of good links and an active news board.

DESIGN IS KINKY
HTTP://WWW.DESIGNISKINKY.NET

HOLODECK 73

HTTP://WWW.H73.COM

This solo project is one of the most popular of the strict Web logs in the land. Mat Mejia, an Los Angeles designer who currently works for Web entertainment company DNA Studios, runs Holodeck. The site is a great place to find old classic personal site links as well as the design that has come in the wake of the Raygun days in Los Angeles. You'll find many more blurred fonts, dirty layouts, and interviews with David Carson here than elsewhere on the Net.

An old favorite of the scene, this site has contributors from Vancouver, Copenhagen, and New York. Though somewhat less active than other posting sites, it also integrates much more in the way of editorial. Its offers include interviews with top designers, lists of top designers' favorite songs, and a permanent list of inspirational links.

KIIROI

HTTP://WWW.KIIROI.NU

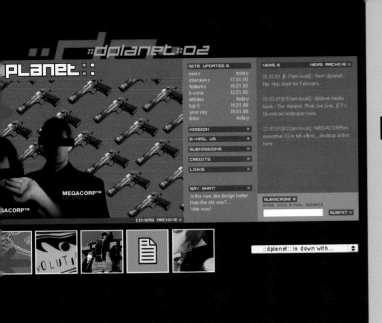

/BACKGROUND

For a look into the assault rifle culture of bandwidth-poor South Africa, check out Damian Stephens' Dplanet. More than most, Dplanet focuses on design theory, and often sports links to impenetrable dissertations from places like MIT. On its lighter site, it features links to sites around the world as well as irreverent art projects, including designer battles, popularity contests, and pointed polls about who has sold out and who hasn't.

/BACKGROUND

Just about the only part of the English language Dmitry Utkin has mastered is gutter profanity, but don't let that turn you off to Factory 512. When not busy swearing, Utkin pours out a torrent of links, and is especially good at picking through the cascade of work coming out of Russia and the Commonwealth of Independent States. The site also has a massive link list and an interesting archive of Utkin's personal artwork and the largest tribute to actress Shannen Doherty on the Net.

ABNORMAL BEHAVIOR CHILD

NICOLA STUMPO
VIA CANONICA 87
20100 MILANO ITALY
PHONE: 39 3470114199
ME@ABNORMALBEHAVIORCHILD.COM
WWW.ABNORMALBEHAVIORCHILD.COM

ARCHINECT

PAUL PETRUNIA
1442 ECHO PARK AVENUE
LOS ANGELES, CA 90026-3348
PHONE: 213.482.2033
MOBILE: 310.403.8153
WWW.ARCHINECT.COM

AUSTRALIAN INFRONT

INFRONT@AUSTRALIANINFRONT.COM
WWW.AUSTRALIANINFRONT.COM

BORN MAGAZINE

GABE KEAN
2138 NW IRVING STREET, #2A
PORTLAND, OR 97210
PHONE: 503.228.5796
GABEK@BORNMAG.COM
WWW.BORNMAGAZINE.ORG

DESIGNGRAPHIK / SUBMETHOD

MIKE YOUNG
YOUNG@WEWORKFORTHEM.COM
WWW.WEWORKFORTHEM.COM
WWW.DESIGNGRAPHIK.COM
WWW.SUBMETHOD.COM

DESIGN IS KINKY

JADE PALMER
MELBOURNE, AUSTRALIA
PHONE: 0401 386 460
JADE@DESIGNISKINKY.NET
WWW.DESIGNISKINKY.COM

DHKY

DAVID YU
WWW.DHKY.COM

DPLANET

DAMIAN STEPHENS
UNIT 11 ROELAND SQUARE
ROELAND STREET
CAPE TOWN 8001
SOUTH AFRICA
PHONE: 27 21 462 5959
WWW.DPLANET.ORG
DPLANET@DPLANET.ORG

ELIXIR STUDIO

ARNAUD MERCIER
ARNAUD@ELIXIRSTUDIO.COM
WWW.ELIXIRSTUDIO.COM

ENERI

IRENE CHAN
INFO@ENERI.NET
WWW.ENERI.NET

FACTORY 512

DMITRY UTKIN
WWW.FACTORY512.COM

FUTURE FARMERS

AMY FRANCESCINI
1201 HOWARD STREET, SUITE B
SAN FRANCISCO, CA 94103
PHONE: 415.552.2124
FAX: 415.626.8953
INFO@FUTUREFARMERS.COM
WWW.FUTUREFARMERS.COM

GMUNK STUDIOS

BRADLEY GROSCH
WWW.GMUNK.COM

HOLODECK 73

MAT MEJIA
4308 CREST DR.
MANHATTAN BEACH, CA 90266
PHONE: 323.868.1137
MAT@DROPPOD.COM
WWW.H73.COM

HUNGRY FOR DESIGN

NANDO COSTA
170 BOULEVARD SE C426
ATLANTA, GA 30312
PHONE: 404.849.5907
THECHEF@HUNGRYFORDESIGN.COM
WWW.HUNGRYFORDESIGN.COM

KALIBER 10000

MIKE SCHMIDT, TOKE NYGAARD,
PER JØRGENSEN
SPEAK@K10K.NET
WWW.K10K.NET

KIIROI

WWW.KIIROI.NU

LINKDUP / PRELOADED

UNIT A6,
8-9 HOXTON SQUARE
LONDON N1 6NU
UNITED KINGDOM
PHONE: 44 0 20 7684 3505
FAX: 44 0 20 7684 3500
REMOTE@PRELOADED.COM
CREW@LINKDUP.COM
WWW.PRELOADED.COM
WWW.LINKDUP.COM

MODULE 8

HENRIK KARLSSON
C&O DOBERMAN
KLIPPGATAN 18
116 35 STOCKHOLM
PHONE: 46 0 709614438
HENRIKK@MODULE8.COM
WWW.MODULE8.COM

NATZKE.COM

ERIK NATZKE
ERIK@NATZKE.COM
WWW.NATZKE.COM

NDROID

VICKI WONG
8 FARNUM STREET
SAN FRANCISCO, CA 94131
PHONE: 415.585.4593
VWONG@NDROID.COM
WWW.NDROID.COM

PRATE

JEMMA GURA
HELLO@JEMMAGURA.COM
WWW.PRATE.COM
WWW.JEMMAGURA.COM

PRECINCT

DANIEL ACHILLES
JOSHUA STREET LTD.
KUNGSKLIPPAN 22
112 25 STOCKHOLM
SWEDEN
PHONE: 46 708 808 555
INFO@PRECINCT.NET
WWW.PRECINCT.NET
WWW.JOSHUASTREET.NET

PRESSTUBE

JAMES PATERSON
PHONE: 514.296.3113
JAMES@PRESSTUBE.COM
WWW.PRESSTUBE.COM

SAUL BASS ON THE WEB

BRENDAN DAWES
WWW.SAULBASS.NET
WWW.BRENDANDAWES.COM

SUBMETHOD

<SEE DESIGNGRAPHIK>

SURFSTATION

THOMAS BRODAHL
FLAT 23 EAGLE HOUSE
31-33 EAGLE WHARF ROAD
N1 7EH LONDON
UNITED KINGDOM
PHONE: 44 0207 684 5362
WWW.SURFSTATION.LU
WWW.XTRAPOP.COM

SUPERBAD

BEN BENJAMIN
557 N GARDNER STREET
LOS ANGELES, CA 90036
PHONE: 323.653.6659
MMMUH@SUPERBAD.COM
WWW.SUPERBAD.COM

THREECOLOR

SPENCER HIGGINS
INFO@THREECOLOR.COM
WWW.THREECOLOR.COM

THREEOH

JAMES WIDEGREN
WWW.THREEOH.COM

TRUE IS TRUE

MICHAEL CINA
CINA@WEWORKFORTHEM.COM
WWW.WEWORKFORTHEM.COM
WWW.TRUEISTRUE.COM

TYPOGRAPHIC

JIMMY CHEN
351 SOUTH COCHRAN AVENUE
LOS ANGELES, CA 90036
PHONE: 323.935.3375
JIMMY@TYPOGRAPHIC.COM
WWW.TYPOGRAPHIC.COM

VOLUME ONE

MATT OWENS
ONE9INE
54 WEST 21ST STREET
SUITE 607
NEW YORK, NY 10010
PHONE: 212.929.7828
MATT@VOLUMEONE.COM
WWW.VOLUMEONE.COM
WWW.ONE9INE.COM

ABOUT THE AUTHOR

Since 1999, Joe Shepter has been an employee at Adobe Systems, Inc., where he helps develop content on its popular community sites at Adobe.com and Adobe Studio. A respected journalist in the fields of Web and graphic design, he has also worked as an interactive writer on movies including *Gladiator*, *Spy Kids*, and *Mark Twain*. Currently, he lives in Palo Alto, CA.

ACKNOWLEDGMENTS

Like most people writing their first book, I have an elephantine list of people to thank. First off are the artists themselves, and all the people who keep the personal site scene lively and active. I'd also like to thank the good folks at Rockport Publishers who took a chance on this book.

In addition, thanks go to Dr. Bruce Mangan, whose writings and conversation are central to my thinking about aesthetic matters. If I said anything intelligent about art in this book, it's entirely his fault. Beyond that, I'd like to thank three friends who kept me in good spirits throughout the writing: Fatima Laklaty, Jimmy Chen, and Sergui "Dis" Podbereschi. The following people were also directly or indirectly helpful in the book: Rodrigo Lopez, Andrew Watanabe, Mark Nichoson, Matt Owens, Josh Davis, Henrik Karlsson, Cameron Campbell, Mike Cina, Daniel Achilles, Damian Stephens, Niko Stumpo, Andy Slopsema, James Widegren, Annette Loudon, Gabe Kean, Mat Mejia, Glenn Mayfield, Mike Schmidt, Brad Johnson, Julie Beeler, Shawn Johnson, Taniesah Evans, Keith Flanagan, George Flanagan, Johnny Broker, Terry Barrett, Matt McDermott, Lance Coughlin, and all the crew at Mansfield Grove who let me sit and write 10,000 words when the sun was out, the air was warm, and the beach was sitting there wondering what was wrong with me.

If you would like your site included in a future book about personal sites, please contact me at shepter@yahoo.com.